Remembering
Orange County

Leslie Anne Stone

TURNER
PUBLISHING COMPANY

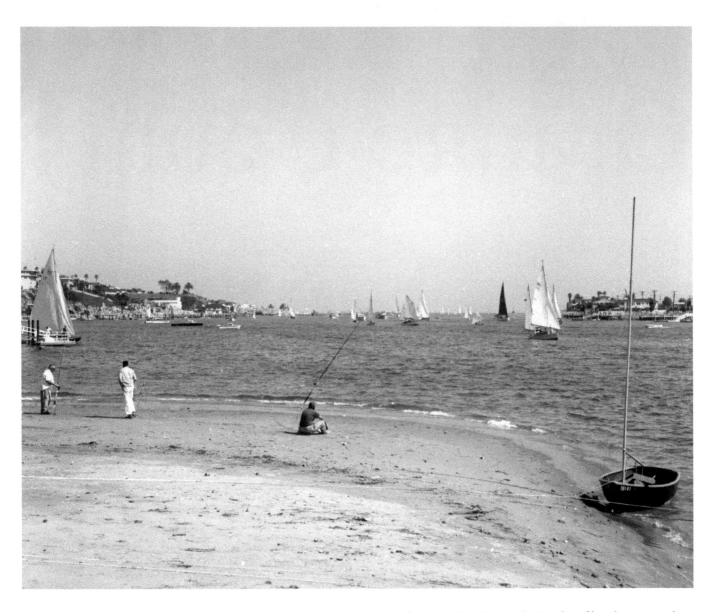

Another idyllic day dawns on Newport Harbor for these early morning anglers in 1960. Newport's 15 miles of beaches received 10 million visitors a year, making the area one of Southern California's top tourist destinations. It's also a popular setting for television shows. In the 1960s, scenes from *Gilligan's Island* were filmed in Newport Beach, and more recently, series based in the area have included *The OC* and *Arrested Development*.

Remembering
Orange County

Turner Publishing Company
4507 Charlotte Avenue • Suite 100
Nashville, Tennessee 37209
(615) 255-2665

Remembering Orange County

www.turnerpublishing.com

Library of Congress Control Number: 2010932274

ISBN: 978-1-59652-700-3

Printed in the United States of America

ISBN: 978-1-68336-867-0 (pbk)

CONTENTS

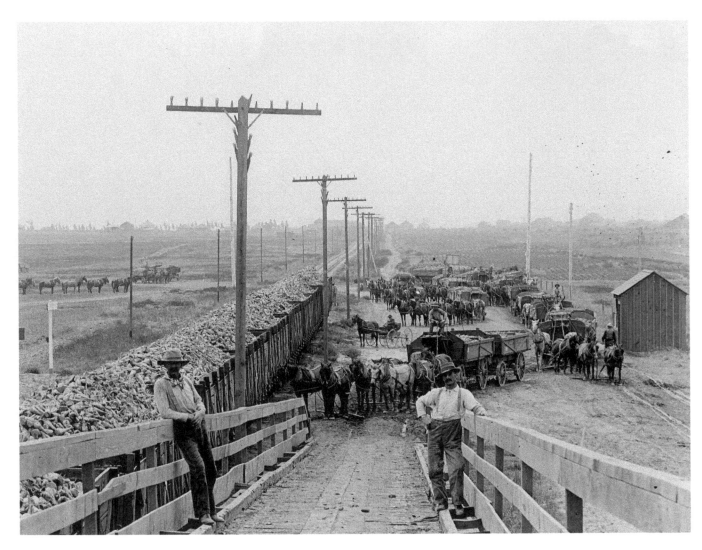

The sugar beet industry flourished in Orange County in the late 1800s. From all over the county, horse-drawn wagonloads of the tan-colored roots were carted to designated railroad collection points, where they were hauled up beet ramps such as this one and dumped into railroad cars for transport to sugar refineries. Sugar beet production declined sharply after the 1920s when curly top, a disease spread by the beet leafhopper, decimated crops.

ACKNOWLEDGMENTS

This volume, *Remembering Orange County,* is the result of the cooperation and efforts of many individuals and organizations. It is with great thanks that we acknowledge the valuable contribution of the following for their generous support:

First American Corporation
Japanese American National Museum
Orange County Archives
Sherman Library

We would also like to thank the following individuals for valuable contributors and assistance in making this work possible:

Charles Beal, Sons of Union Veterans of the Civil War
Phil Brigandi, Orange County Archives
Dean Dixon, Buena Park Historical Society
Chris Jepson, Orange County Archives
Irma Morales, Orange Public Library, El Modena Beach

Preface

Orange County has thousands of historic photographs that reside in archives, both locally and nationally. This book began with the observation that, while those photographs are of great interest to many, they are not easily accessible. During a time when Orange County is looking ahead and evaluating its future course, many people are asking, How do we treat the past? These decisions affect every aspect of the region—architecture, public spaces, commerce, infrastructure—and these, in turn, affect the way that people live their lives. This book seeks to provide easy access to a valuable, objective look into the history of Orange County.

The power of photographs is that they are less subjective than words in their treatment of history. Although the photographer can make subjective decisions regarding subject matter and how to capture and present it, photographs seldom interpret the past to the extent textual histories can. For this reason, photography is uniquely positioned to offer an original, untainted look at the past, allowing the viewer to learn for himself what the world was like a century or more ago.

This project represents countless hours of review and research. The researchers and writer have reviewed thousands of photographs in numerous archives. We greatly appreciate the generous assistance of the archivists listed in the acknowledgments of this work, without whom this project could not have been completed.

The goal in publishing this work is to provide broader access to sets of extraordinary photographs that seek to inspire, provide perspective, and evoke insight that might assist people who are responsible for determining Orange County's future. In addition, the book seeks to preserve the past with adequate respect and reverence.

With the exception of touching up imperfections that have accrued with the passage of time and cropping where necessary, no changes have been made. The focus and clarity of many images are limited to the technology and the ability of the photographer at the time they were taken.

The work is divided into eras. Beginning with some of the earliest known photographs of Orange County, the first section records photographs through the end of the nineteenth century. The second section spans the turn of the century through World War I. Section Three moves from the 1920s through World War II. The last section covers the postwar years to the 1960s.

In each of these sections we have made an effort to capture various aspects of life through our selection of photographs. People, commerce, transportation, infrastructure, religious institutions, and educational institutions have been included to provide a broad perspective.

We encourage readers to reflect as they go walking in Orange County, strolling through its cities, its parks, and along its beaches. It is the publisher's hope that in utilizing this work, longtime residents will learn something new and that new residents will gain a perspective on where Orange County has been, so that each can contribute to its future.

—*Todd Bottorff, Publisher*

The town of Santa Ana was laid out in 1869 by William Spurgeon, a 40-year-old adventurer from Kentucky who chose the site for its proximity to the more established areas of Anaheim, Tustin, and Orange. Less than 20 years later, at the time this photograph was taken, Santa Ana was a thriving community with a population of 3,600 and a central business district composed of two-story brick buildings that conveyed stability and permanence.

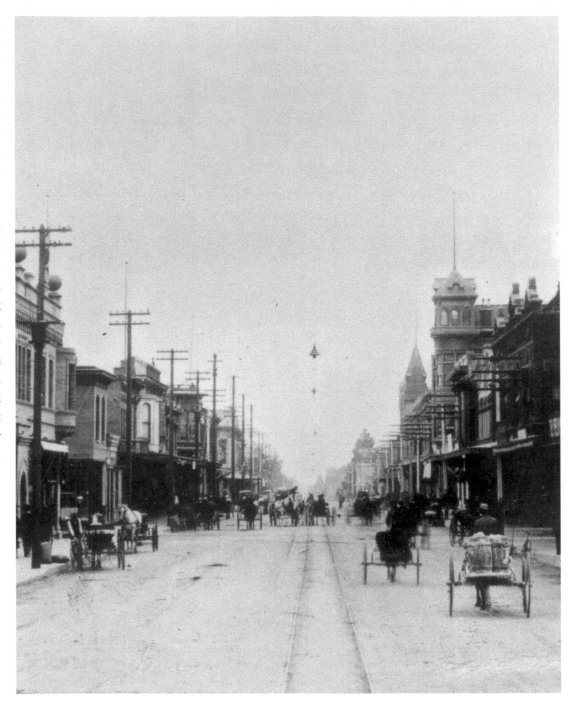

Changing Beauty and Ceaseless Fruition

(1870s–1899)

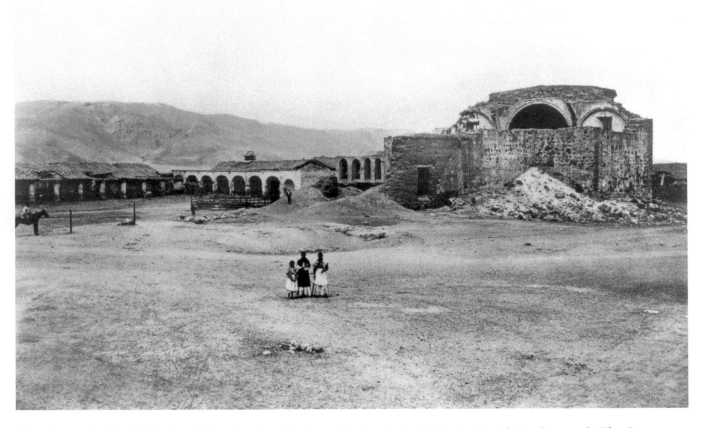

Once the jewel of the California missions, San Juan Capistrano lay in ruins by 1876, the date of this photograph. The Great Stone Church, at right, functioned as a chapel for only six years before a massive earthquake leveled it in 1812, tragically killing 40 worshipers inside. After nearly a century of intermittent restoration efforts, the mission today is an international tourist destination.

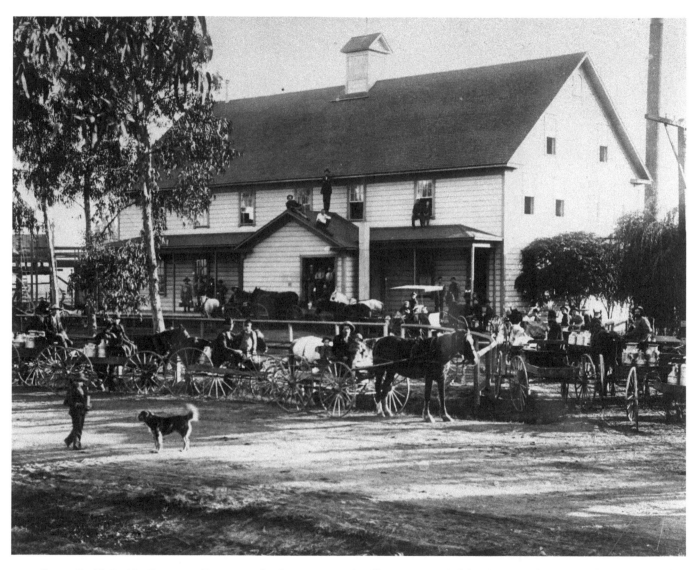

Buena Park's Pacific Creamery Company, the first evaporated-milk cannery in California, opened in 1889, the same year that Orange County split off from Los Angeles County. The company's "Lily California Sterilized Cream" won gold medals at the Buffalo Pan-American Exposition of 1901 and the Paris Exposition of 1903, and in large part sustained the local economy for many years. The building was torn down in 1955 to make way for a freeway.

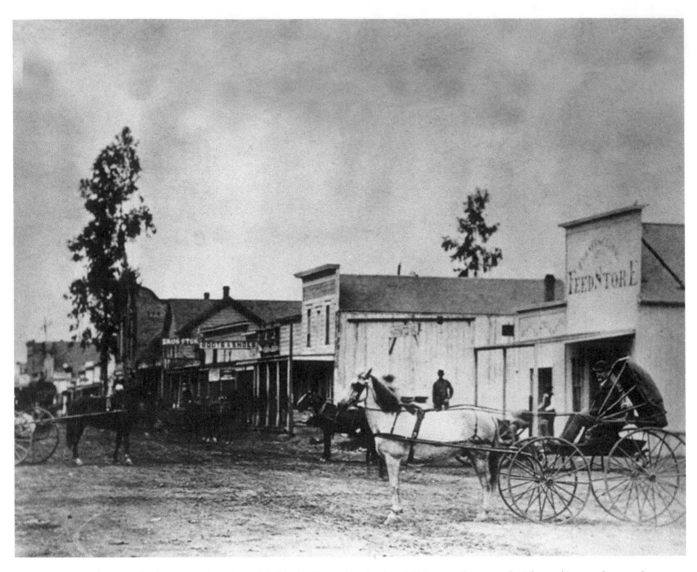

Mr. C. E. French sits in his buggy at Fourth and Main in Santa Ana in this 1890s-era photograph. The earliest settlers to the area that would become Santa Ana arrived from the Midwest in the mid-1860s, finding waist-high mustard grass, cactus, and not much else. Lumber was scarce and had to be shipped from northern California to Anaheim Landing (now Seal Beach Naval Station). Early businesses such as these were simple, unpainted board and batten structures.

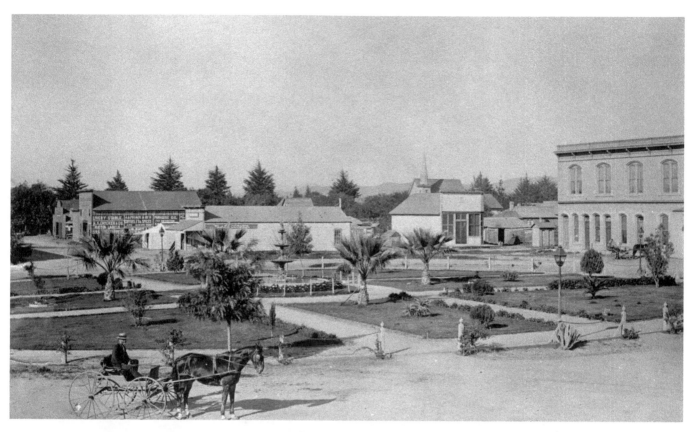

Orange city founder Captain Glassell was no doubt influenced by the City Beautiful movement of the late nineteenth century in planning a city where all businesses would face the scenic central Plaza. Though many of the lots ringing the Plaza were still vacant in 1898, the year of this photograph, a three-tiered fountain had been installed, and streetlights, sidewalks, fence posts, and the rudiments of landscaping are all evident.

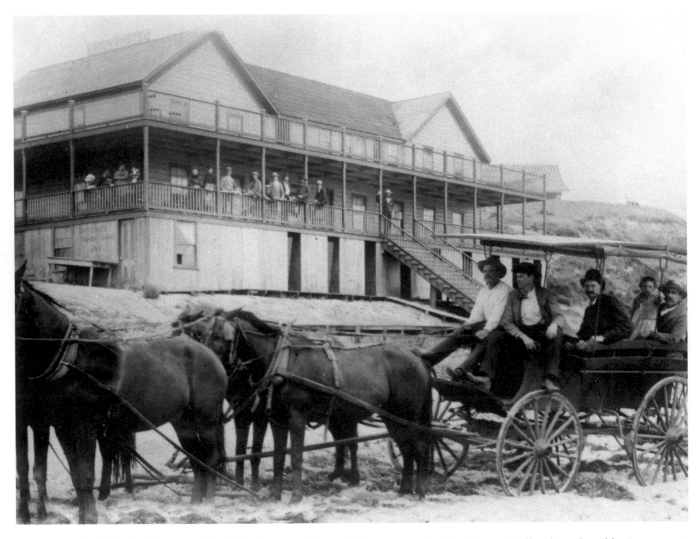

Laguna Beach's Yoch Hotel, pictured in 1889, the year of its establishment, was built by Henry Goff and purchased by Laguna Beach postmaster Joseph Yoch for $600. By the standards of the time, the Yoch Hotel was enormous, with 32 rooms and 2 bathrooms. In an area where lumber was scarce, the Yoch's formidable bulk was achieved through the rather unconventional method of joining sections of another defunct hotel to the core structure.

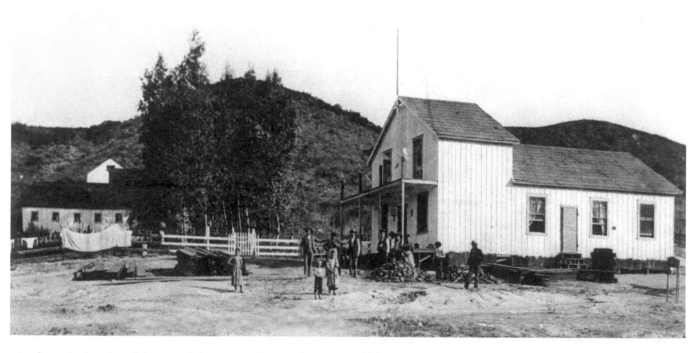

In the early decades of the twentieth century, Orange County would have three hot-springs resorts. San Juan Hot Springs, shown here in 1890, was located in a scenic canyon 12 miles east of San Juan Capistrano. A successful resort operated there from 1883 to 1936, promising to cure everything from rheumatism to melancholia with its 122-degree mineral waters. The resort was reopened in 1980 but fell victim to freeway expansion just 12 years later.

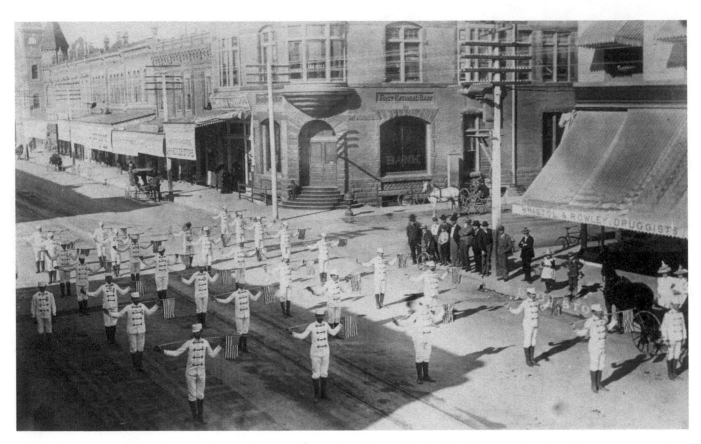

A drill team marches down Santa Ana's Fourth Street past the First National Bank. The three-story brick building, crowned with a corner tower, was built at a cost of $45,000 at the height of the late-1880s land boom. Other substantial brick buildings built in Santa Ana's downtown area during the same period include the elegant 75-room Brunswick Hotel, as well as many fine Victorian homes, such as the famed Howe-Waffle House.

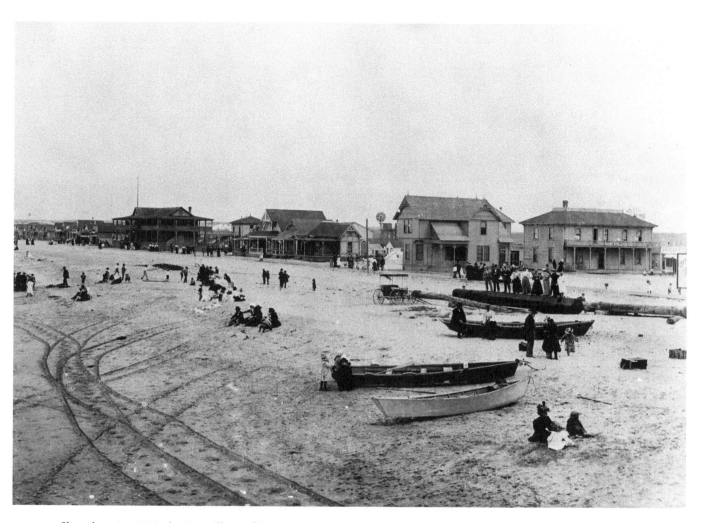

Show here in 1895, the tiny village of Newport Beach seems to have sprouted from the sand. Sharp's Hotel, the two-story wood structure at right, was brought to town in pieces—dismantled at its previous location south of San Juan Capistrano and reassembled on the beach. The building served 18 years as a boardinghouse for wharf workers and became famous for its fish dinners. It burned to the ground in 1910.

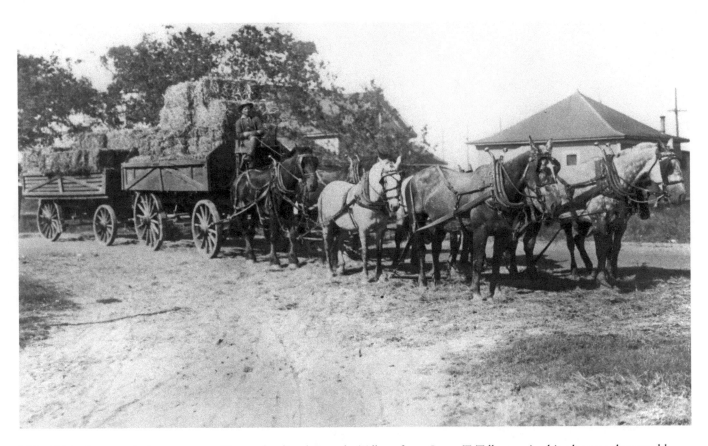

This 1890s photograph shows a team of horses hauling hay at the Talbert farm. James T. Talbert arrived in the area that would become Fountain Valley in 1896 and purchased 322.5 acres of swampland. Construction of the Talbert Drainage District reclaimed the swampland for agricultural use, and the area was soon known for bean and beet production. Talbert's three sons—Sam, Tom, and Henry—became involved in farming also, and in real estate.

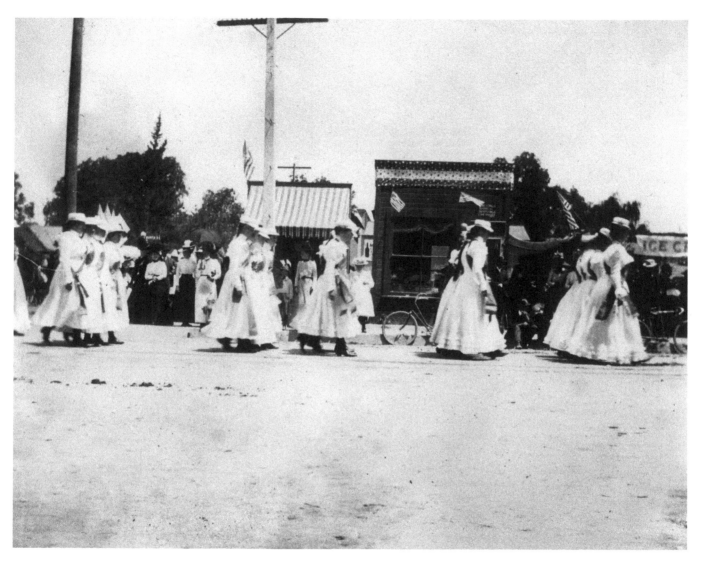

A woman's group marches down Fourth Street in a turn-of-the-century Santa Ana parade. Orange County has a rich tradition of unique community parades. Dana Point and San Juan Capistrano mark the annual whale and swallow migrations, respectively, with their March parades. La Habra's Corn Festival celebrates the September harvest. And, of course, Disneyland presents its renowned high-tech parade of Disney characters nightly in Anaheim.

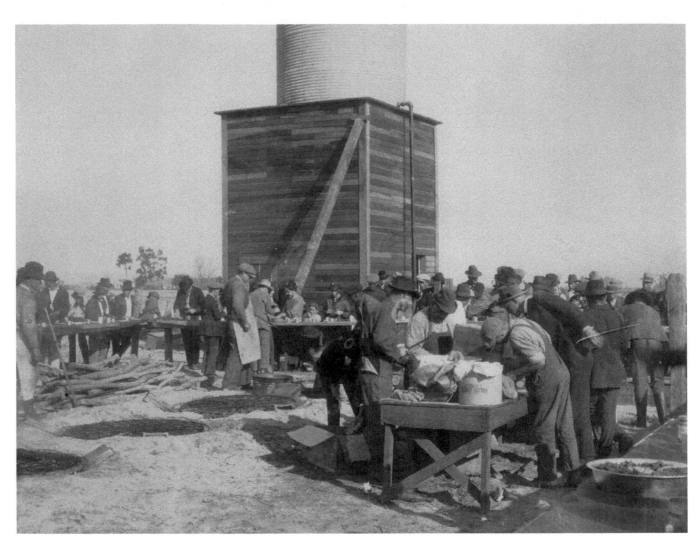

During the late-1880s land boom, real estate agents attracted prospective investors to remote Orange County with rosy hyperbole and fun-filled outings that included bands, entertainment, and a picnic lunch. Here guests at Henry Talbert's ranch are fed a barbecue meal in an attempt to loosen their wallets. A vat of what appears to be baked beans sits on the table at right.

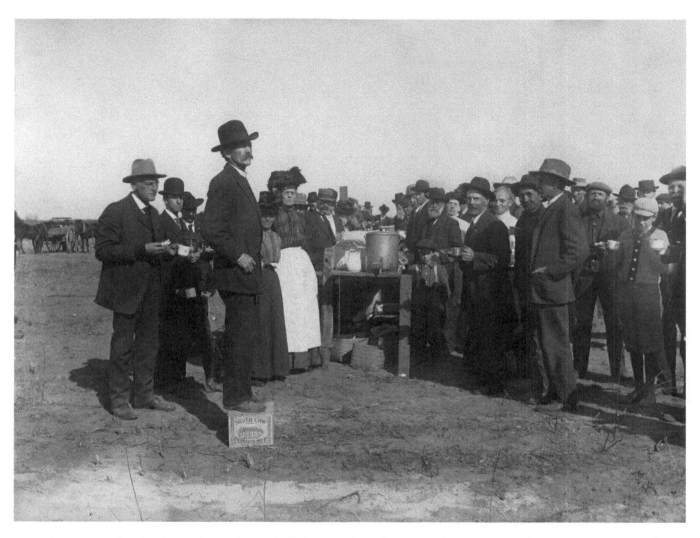

A prosperous-looking farmer (a member of the Talbert family, perhaps?) stands on a crate of Silver Cow evaporated milk and addresses a rapt audience. Their stomachs full, they sip their coffee and dream about the bright future that could—and did— await those who purchased land in fertile, temperate Orange County.

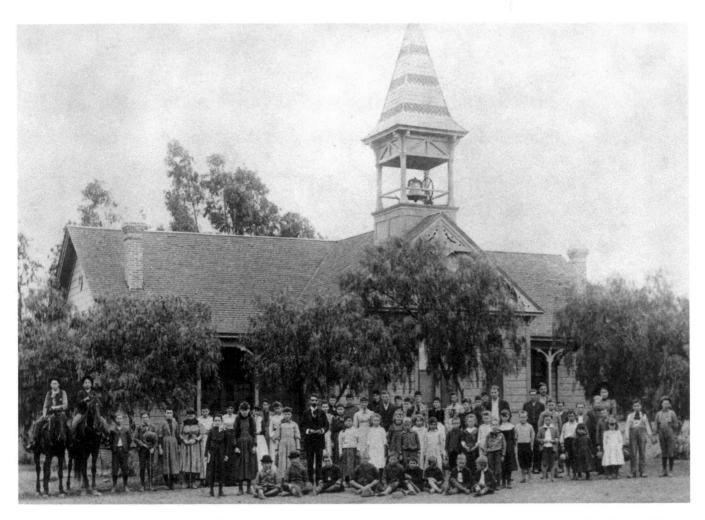

Mountain View School, so named for the scenic hills surrounding it, opened in 1881 and is seen here about a decade later. The community it served was also known then as Mountain View, but was incorporated as Villa Park in 1962 to avoid annexation by the city of Orange. Villa Park, whose motto is the "Hidden Jewel," is today Orange County's smallest city in terms of population, an exclusive enclave completely surrounded by Orange.

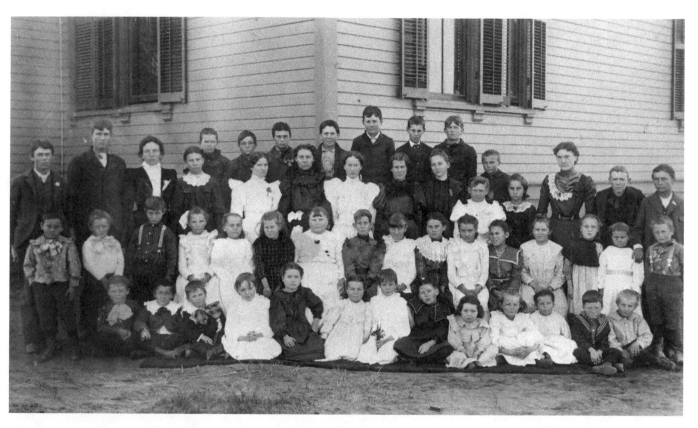

Buena Park's first schoolhouse was built in 1892 and opened with 23 students. By 1898, when this photograph was taken, attendance had more than doubled, with fully 10 percent of the student body composed of various members of the Moody family, after whom a city street was later named. County records valued the property at $3,950 and listed 226 books in the school library. Buena Park today is served by seven different school districts.

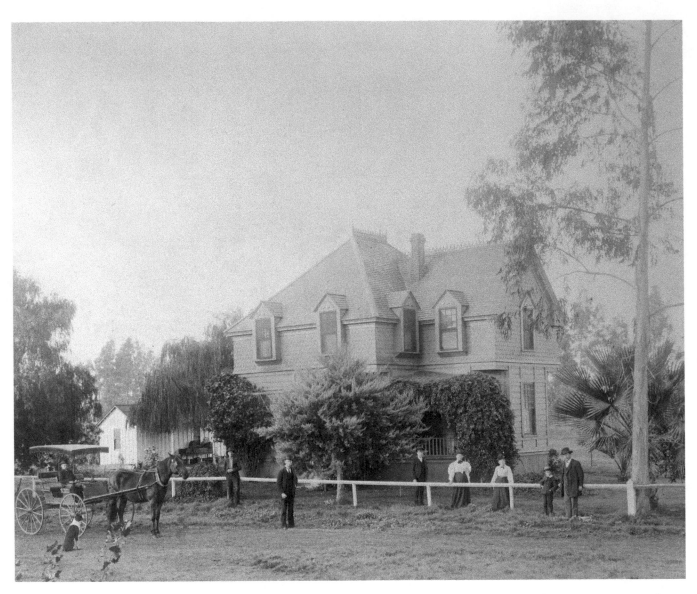

The first standing house in the area that would become Buena Park was a squatter's shack that appeared in a remote corner of Rancho Los Coyotes around 1884. By 1896, the year of this photograph, many fine homes such as this one belonging to the Reis family had been constructed.

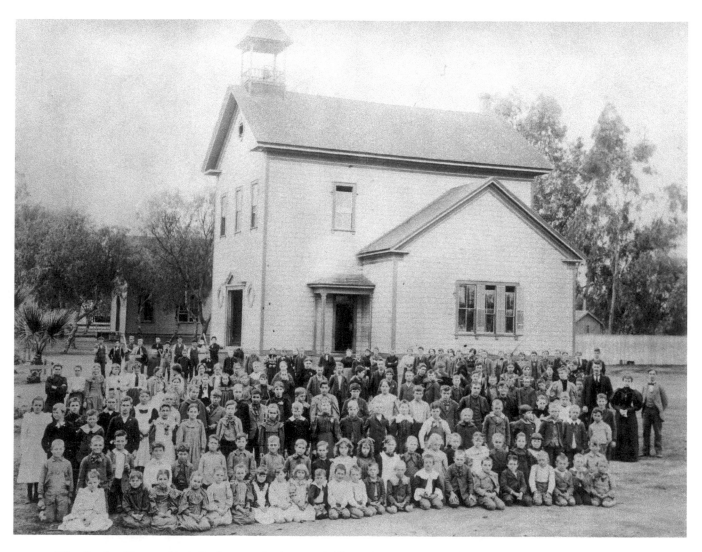

The Garden Grove school district organized in 1874. Shown here in 1897 is the entire student body posing in front of the schoolhouse. The children in the back row at left appear to be holding baseball equipment. Garden Grove remained a small rural crossroads between Anaheim and Santa Ana until the arrival of the railroad in 1905. Today the city is famed for Robert Schuller's Crystal Cathedral.

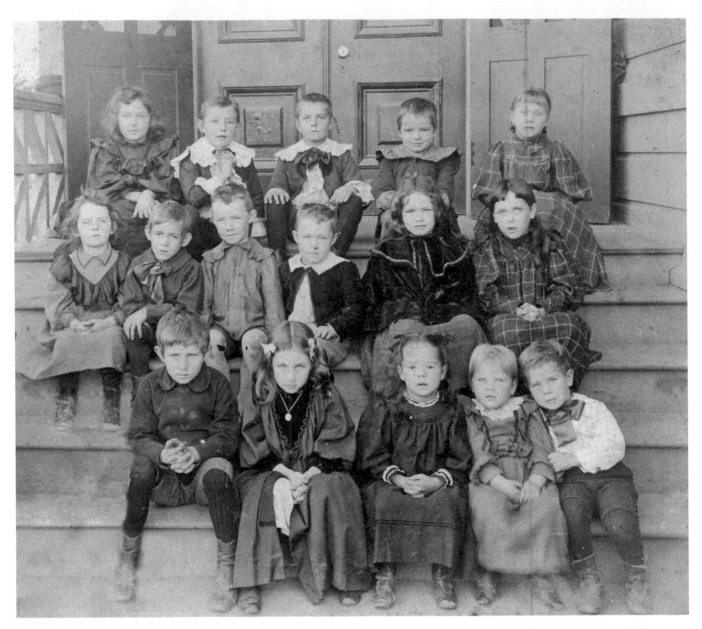

In 1898, the year this photograph was taken, the city of Orange was home to Protestants of various denominations, including Methodist, Presbyterian, Lutheran, Baptist, and Episcopalian. Shown here are the youngest members of First Christian Church, established in 1883 at the corner of Chapman and Grand. In 1961, the church moved to a new building on Walnut Avenue, which still stands.

The Biggest Little County in the West

(1900–1919)

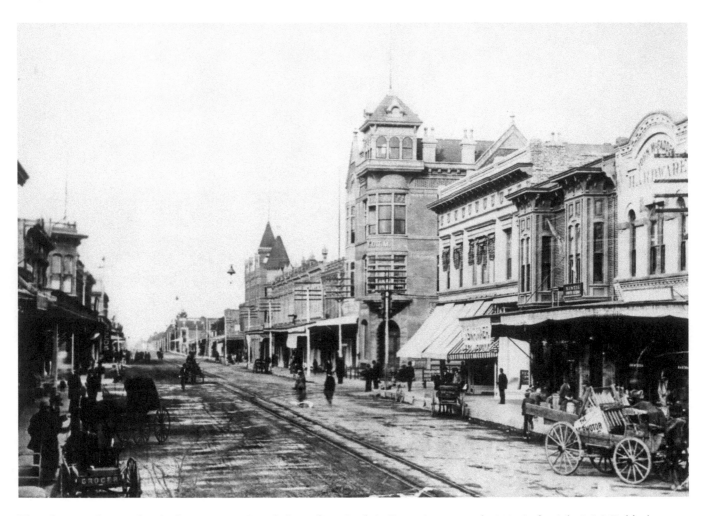

This photograph was taken looking west on Fourth Street from Bush in Santa Ana, around 1900. At far right is McFadden's Hardware, opened in 1879 by John McFadden. McFadden was one of four brothers who settled in Orange County in the 1870s and played significant roles in the development of Santa Ana and Newport Beach. His brothers James and Robert built the McFadden Wharf that ushered in Newport's decade as a shipping port.

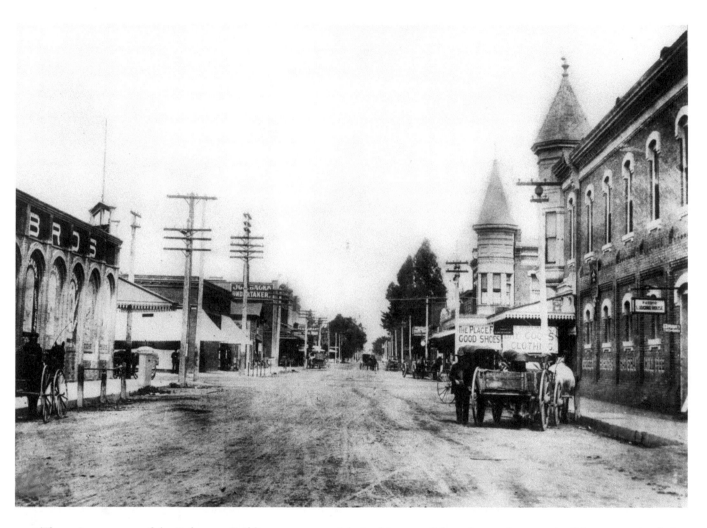

The unique turrets of the Federman Building are seen at right in this turn-of-the-century photograph of downtown Anaheim. In 1870 Anaheim became the first Orange County city to incorporate, but it lost the bid for county seat in 1889 to rapidly growing Santa Ana. Anaheim would not regain its preeminence in the county until 1955 with the opening of Disneyland, which quickly turned the city into a worldwide tourist destination.

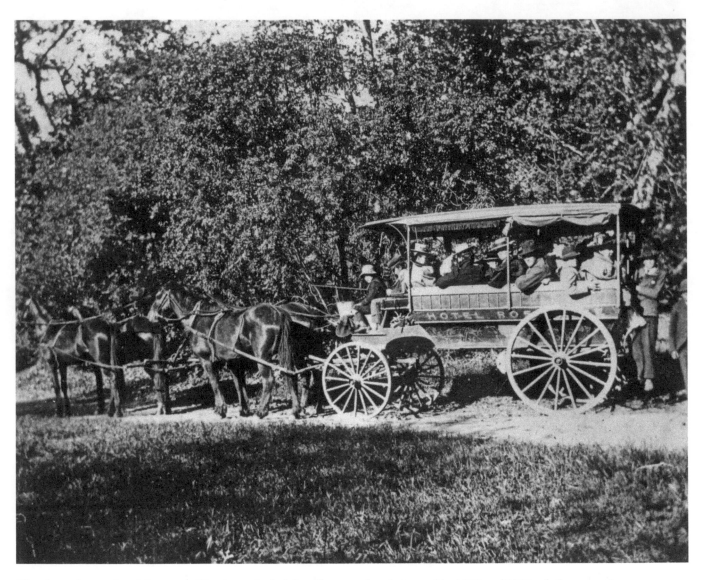

The elegantly appointed Rossmore Hotel was the height of luxury when it opened in 1887 at 406 North Sycamore in Santa Ana, even going so far as to provide its guests with the nineteenth-century equivalent of a shuttle bus. The "Tally Ho" bus, shown here around 1900, was a horse-drawn stagecoach that ran between the hotel and Irvine Park—a popular recreational site then and now, and OC's first park.

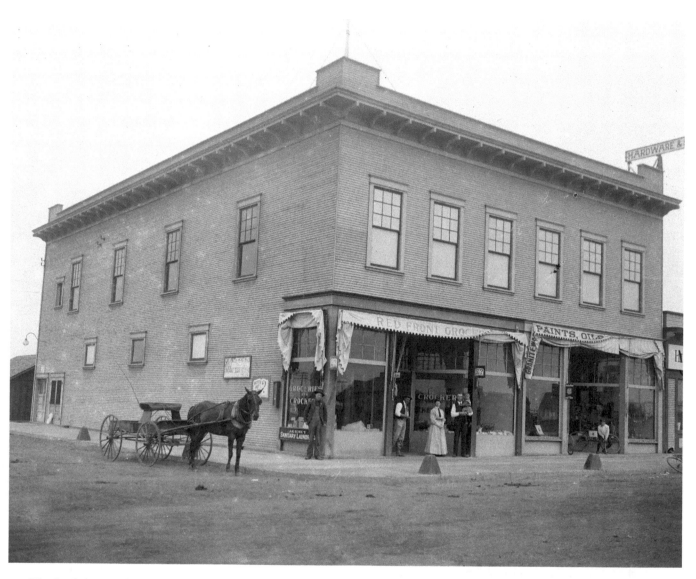

The land that would one day become Huntington Beach was purchased in 1901 by the West Coast Land and Water Company syndicate, which hoped to turn the area into a resort called "Pacific City," the West Coast equivalent of Atlantic City. This commercial building on Main Street house Stewart Meeting Hall on the top floor and a combination grocery and hardware store on the lower level to serve the needs of the hoped-for influx of settlers.

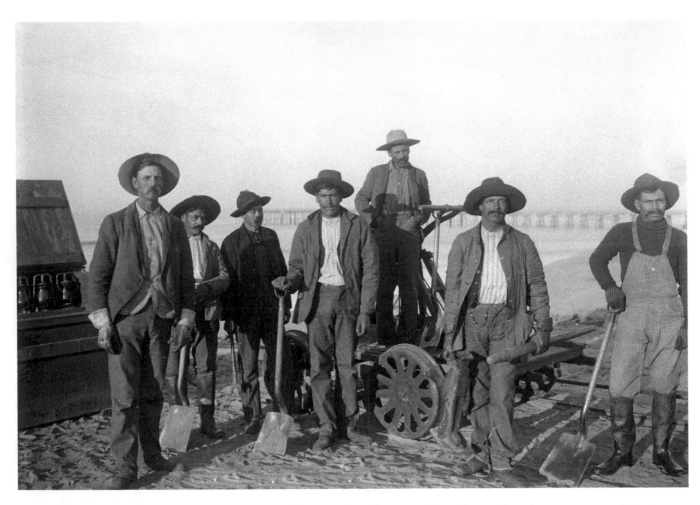

Huntington Beach at one point was served by three different railroad lines, providing plenty of employment opportunities for crews such as this one, hired to lay and maintain tracks. The hard-working crew poses on a handcar with the Huntington Pier just visible behind them in this photo from the early 1900s. The wooden box at left stores red warning lanterns that were hung around job sites, serving much the same function as traffic cones today.

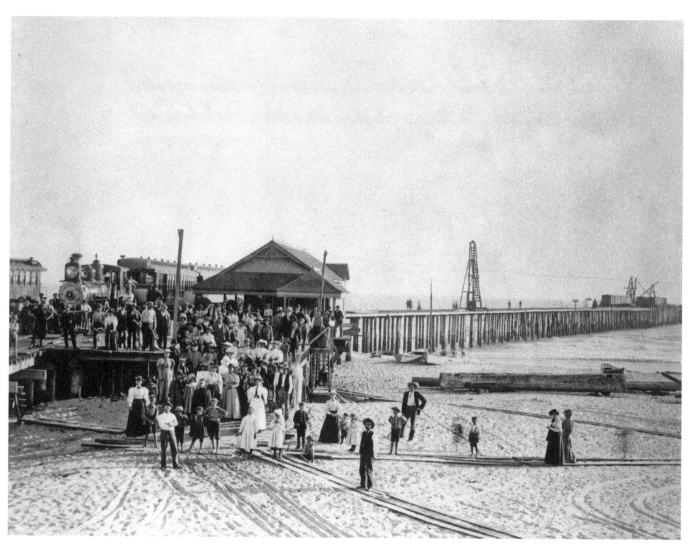

Passenger service from Santa Ana to Newport Beach on the Santa Fe Railroad started in 1891. The 11-mile route took 12 minutes—a fraction of the time it would take to drive the same distance today. The arrival of the train at McFadden Wharf was cause for much excitement; the whole town would flock to the station to see who had arrived and to get the latest news.

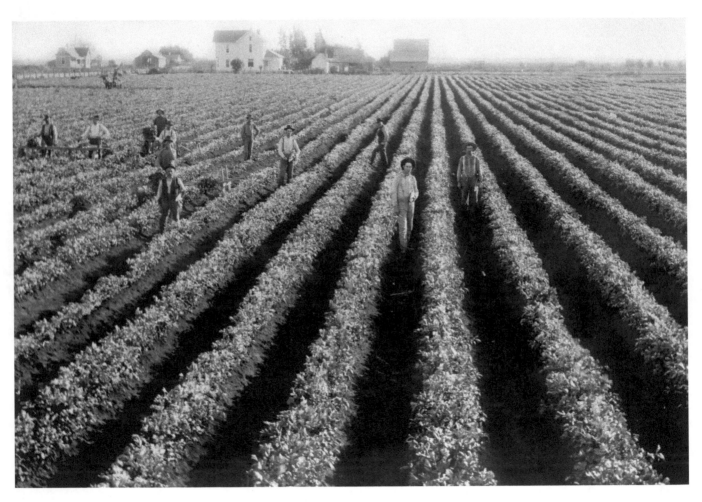

Founded in 1870 as a temperance colony, Westminster experienced brief success as a center of celery production, despite repeated harassment of its many Chinese immigrant farm workers, and the marshy conditions that necessitated outfitting the horses with "peat shoes" to keep them from sinking into the mud. Disease wiped out the crops in the early 1900s, not long after the time of this photograph. Westminster today is known as Little Saigon, due to its large population of Vietnamese Americans.

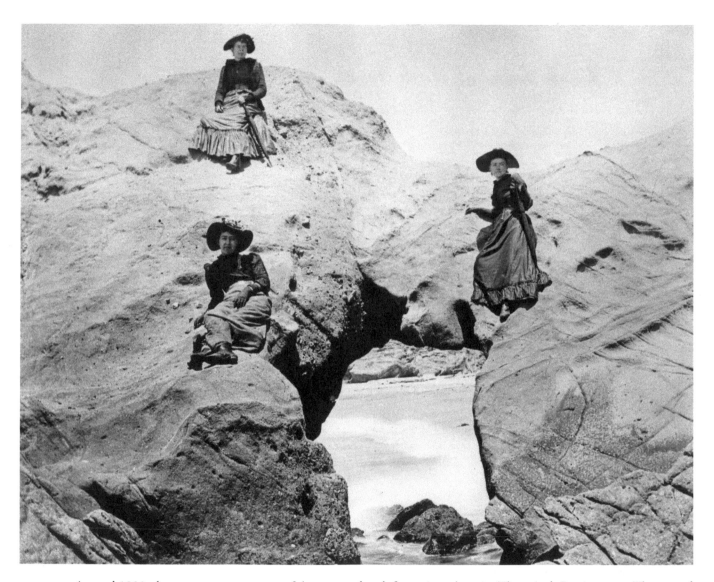

Around 1900, three women pose at one of three natural rock formations that give Three Arch Bay its name. The rugged topography of this scenic beach just south of Laguna has been the muse of many. It was here that Errol Flynn fought off pirates in the swashbuckling 1935 film *Captain Blood,* and that Hollywood luminaries like Edith Head, Fredric March, and Sterling Holloway made their homes.

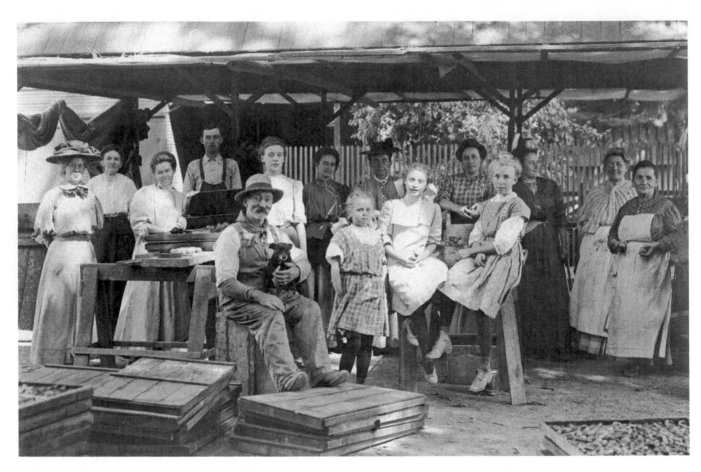

Dried apricots were a profitable business for the two decades leading up to World War I. Most harvesting was done by locals—often girls and boys on summer break from school—working in temporary apricot-picking camps under improvised awnings at the side of the road. Boys did the picking and girls did the halving, a task involving sharp knives and hands drenched in sticky juice.

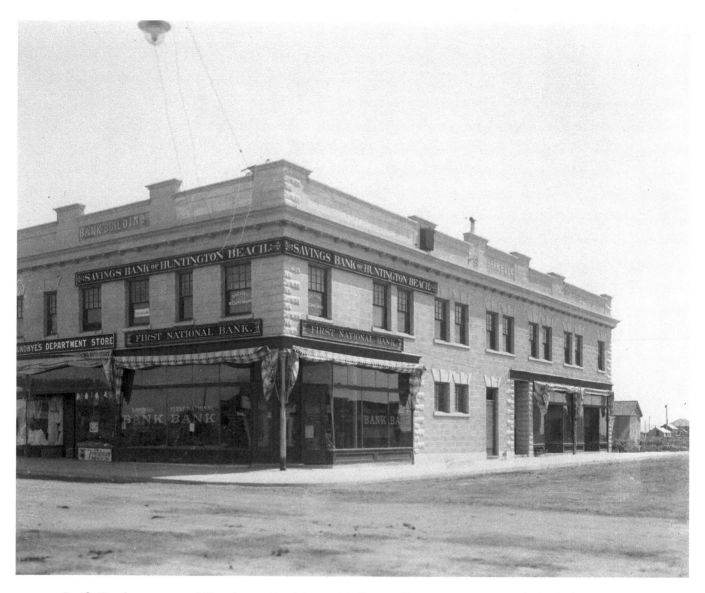

Pacific Beach was renamed Huntington Beach in 1903 in honor of Henry Huntington, who built the town's first pier and extended a line of his Pacific Electric Railway to it. The resulting land boom caused the price of lots to skyrocket from $200 and acre to $3,000, and a commercial center quickly developed on the high bluff overlooking the ocean. Shown here is the First National Bank building on Main Street.

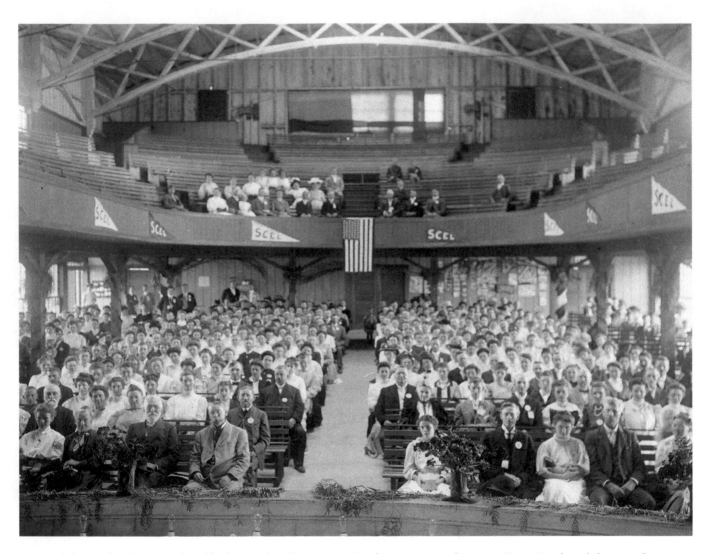

By 1904 the Pacific Electric Railroad had arrived in Huntington Beach, connecting the city to Long Beach and the rest of Los Angeles County, and city boosters were eager to attract tourists. Soon they lured the Methodist convention away from Long Beach by donating a large campsite and building a 3,000-seat auditorium for them. In this photo the auditorium is hosting a meeting of the Epworth League, a Methodist youth organization.

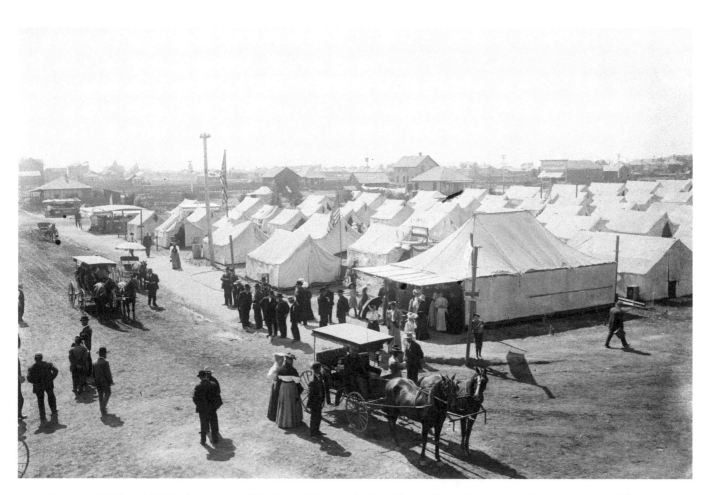

Between 1905 and 1920, the open land in front of the Methodist Tabernacle Auditorium in Huntington Beach became a sea of tents in the summer months, hosting at various times Grand Army of the Republic encampments, Methodist revivals, and Socialist meetings. This photograph likely shows a group of Methodists gathered to attend an Epworth League convention.

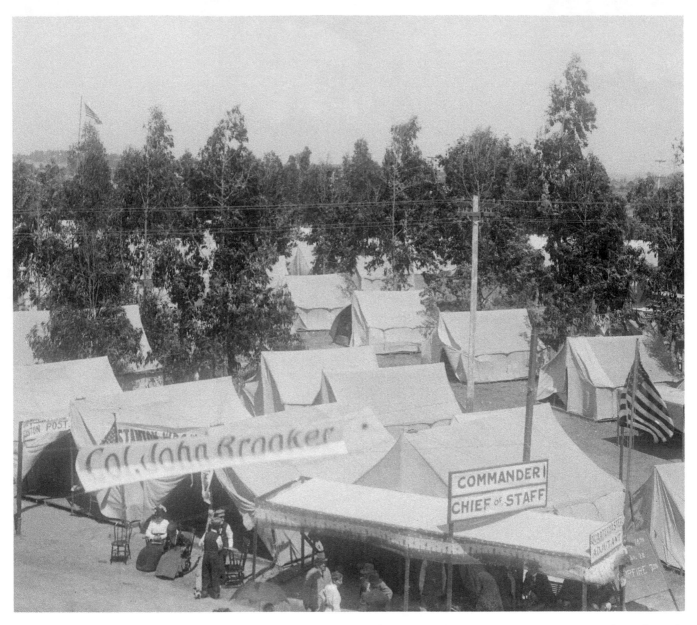

The Grand Army of the Republic, established in 1866, was one of the first organized interest groups in American politics, formed to lobby for pension legislation. The group also held regular encampments, such as this 1911 regional gathering in Huntington Beach, an event named in honor of Colonel John Brooker, veteran of the Battles of the Wilderness and Spotsylvania. Colonel Brooker died in 1909 and was buried in nearby Artesia Cemetery.

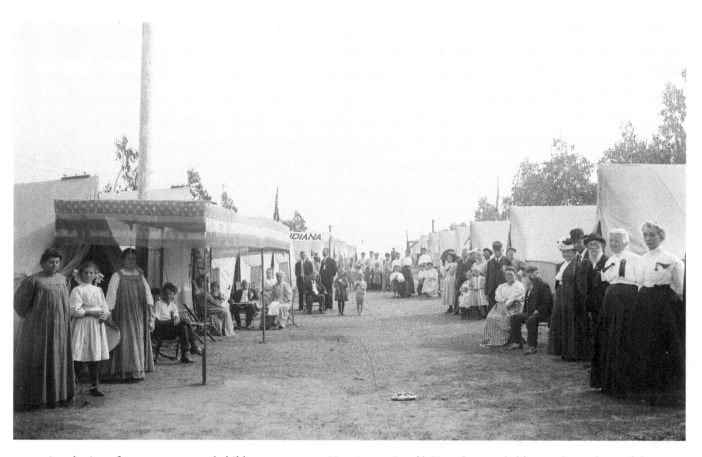

A gathering of men, women, and children convenes at Huntington Beach's Tent City, probably members of one of the many women's auxiliary organizations generated by the Grand Army of the Republic, such as the National Woman's Relief Corps, Ladies of the GAR, or Daughters of Union Veterans of the Civil War.

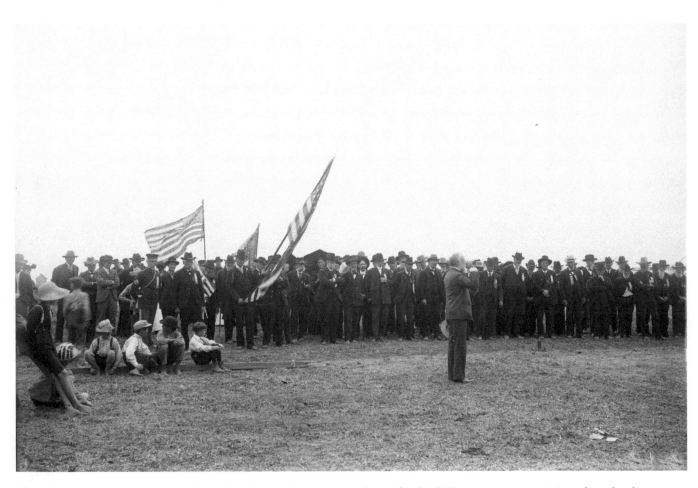

The typical GAR encampment, such as this 1905 gathering, was a chance for Civil War veterans to reminisce about battle experiences, remember fallen comrades, and raise funds for monuments and other worthy causes. But it was also a time of great pomp and pageantry, featuring the posting of the colors, parades, grand patriotic vocal and instrumental concerts, awards ceremonies, formal banquets, fife and drum corps, and speeches by dignitaries.

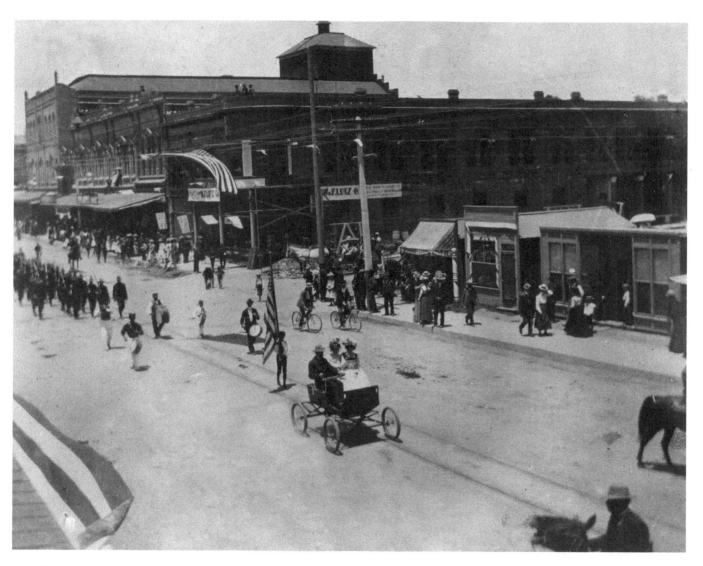

The completion of the Pacific Electric Railway line from Los Angeles to Santa Ana cemented the city's status as a major player and was celebrated in 1906 by the first annual Parade of Products. The inaugural event included 33 horse-drawn floats, each promoting a different Orange County agricultural product, such as honey, celery, and poultry. The event also included, as shown here, a contingent of veterans of the Spanish-American War.

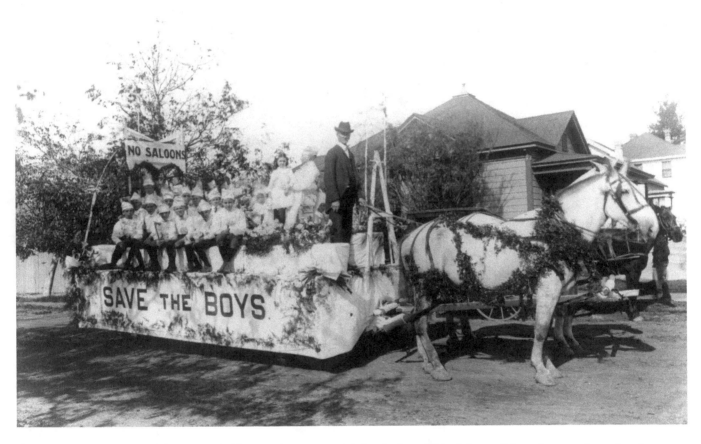

The Los Angeles chapter of the Women's Christian Temperance Union had established the tradition of sponsoring a float in the Pasadena Rose Parade, and the chapter to the south in Orange County saw an opportunity to follow suit with the Parade of Products. A dozen prepubescent teetotalers rode along on the white float with the WCTU members who promulgated their abstinence agenda by chanting "Never! Never! Never! Santa Ana free forever!"

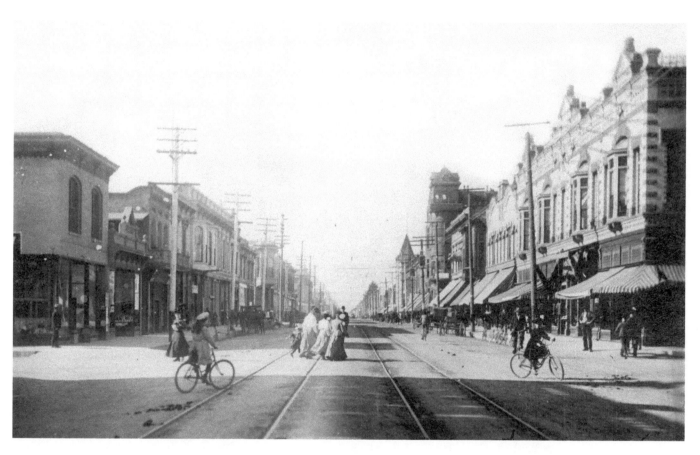

Two young Santa Ana ladies ride their bicycles across the recently installed railroad tracks on Fourth Street in this 1907 view. Shortly after the city incorporated in 1886, the newly elected board of trustees set to work establishing law and order within the city limits. Among the laws enacted was one prohibiting the riding of bicycles on sidewalks by anyone over the age of ten.

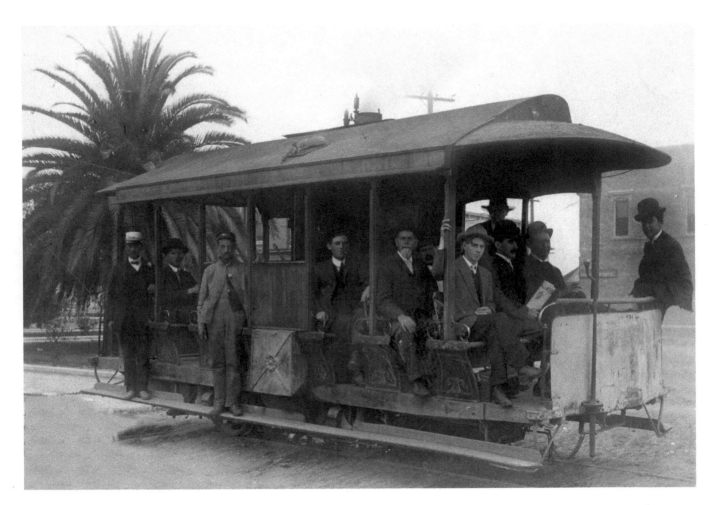

Far from being odorless, smokeless, and noiseless, as promoted, the Dummy was an oil-burning, steam-driven motorcar that spooked horses, belched sticky black smoke, and moved at a languorous pace. Conceived by the Tolle brothers (Ed Tolle is standing at the rear of the car in this 1907 photograph), the Dummy, or "Peanut Roaster," ran on narrow-gauge railroad tracks between Santa Ana and Orange for almost 20 years.

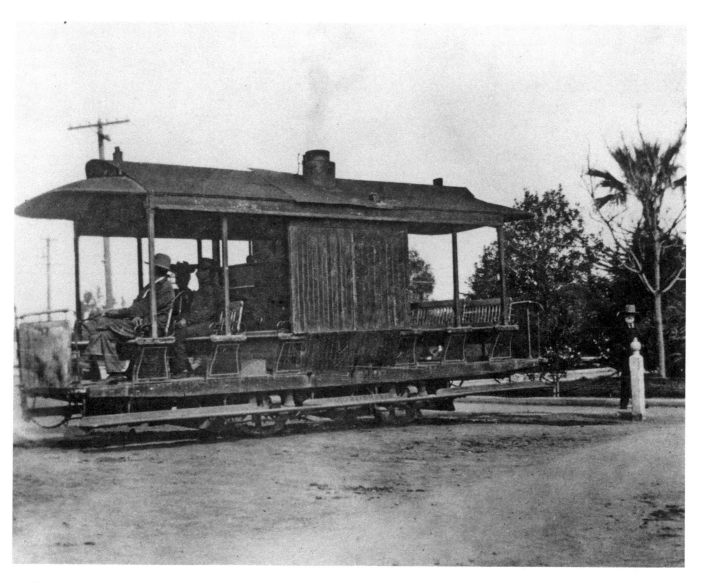

The Orange Dummy, seen here from the other side, was 20 feet long and carried up to 24 passengers at speeds of eight miles an hour. The Dummy was essentially a stopgap measure between the outmoded horsecar lines of the Santa Ana, Orange and Tustin Street Railway Company, and the completion of the Pacific Electric Red Car line from Los Angeles to Santa Ana in 1906.

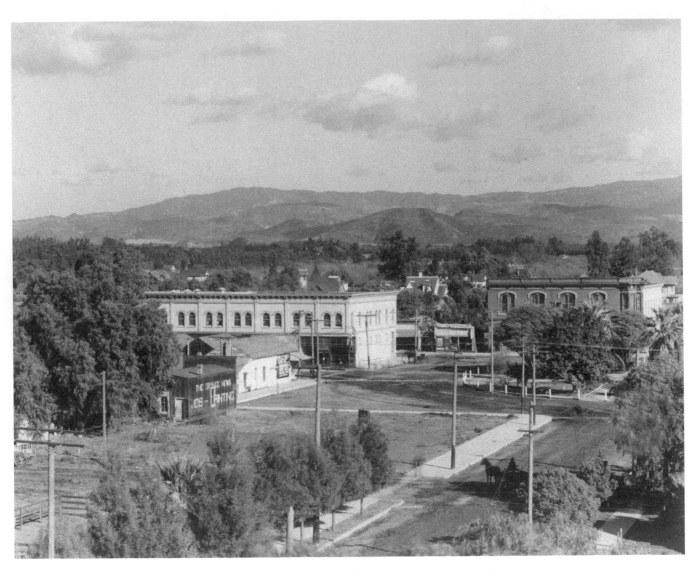

In 1907 the rustic offices of the *Orange News,* at far left, were dwarfed by the far grander edifices of the Edwards Block, at center, and the Bank of Orange, at right. These monumental structures, so seemingly out of place against the rural landscape, reflected the architectural ideals of the 1893 Chicago World's Fair, which would influence city planning for decades to come.

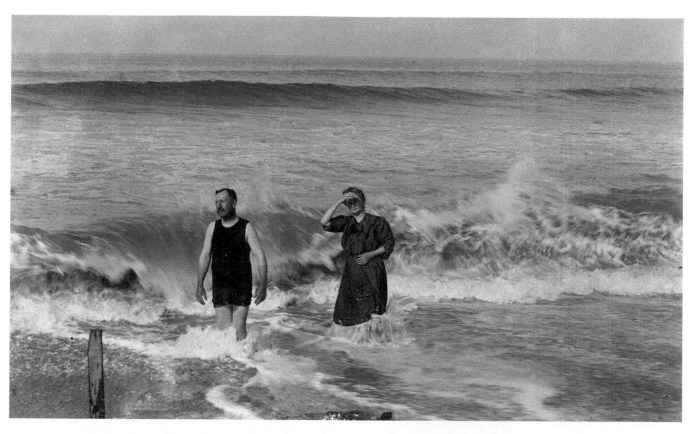

A fun-loving couple models the latest in lightweight wool bathing attire while frolicking in the waves at Huntington Beach in 1908. Huntington Beach boasts eight miles of wide, uninterrupted beachfront, the largest stretch on the West Coast, and is intentionally known for surfing. In 2006, the city's Conference and Visitors Bureau trademarked the expression "Surf City USA," which led to legal battles with beachwear retailers in the city of Santa Cruz.

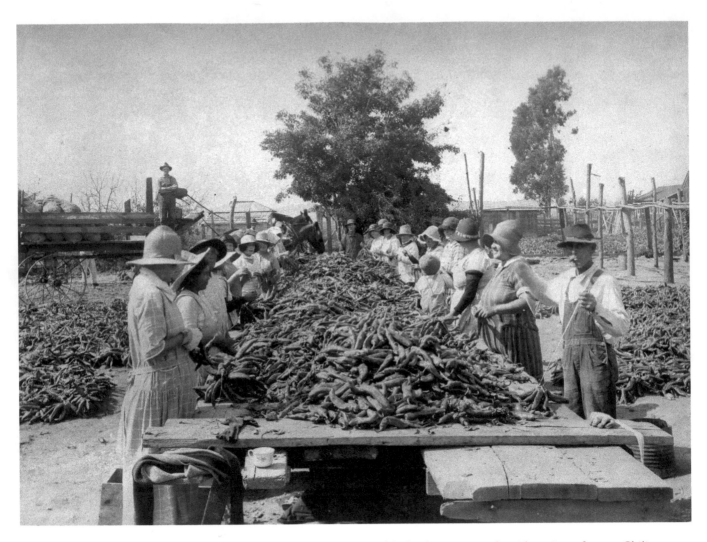

The sandy soil and temperate climate of Orange County proved amenable for the growing of a wide variety of crops. Chili pepper production started around 1890 near Anaheim and was so successful that Orange County was soon providing all of the chilis grown in California. Mexican chilis and Anaheim chilis were two particularly popular varieties. Unfortunately, like so many other early crops, the industry was destroyed by a parasite, in this case, the chili weevil.

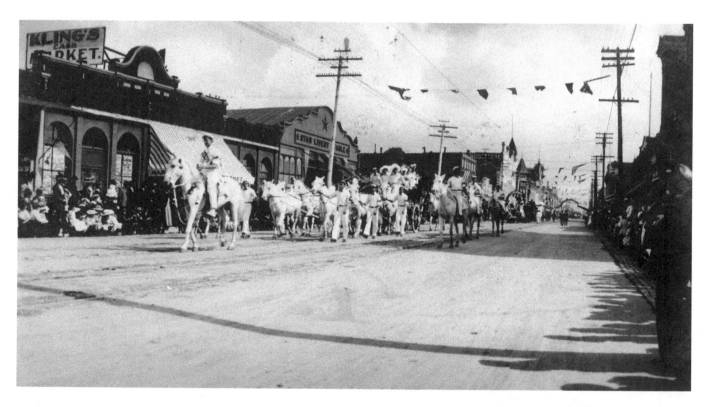

In 1908, the enrollment of Orange Union High School was only about a hundred students, so it would appear that a large percentage of the student body participated in the school's entry in Santa Ana's third annual Parade of Products, shown here. OUHS, established in 1903, was the fourth high school in the county. Prior to its formation, Orange Elementary School graduates had to travel to Santa Ana for higher education.

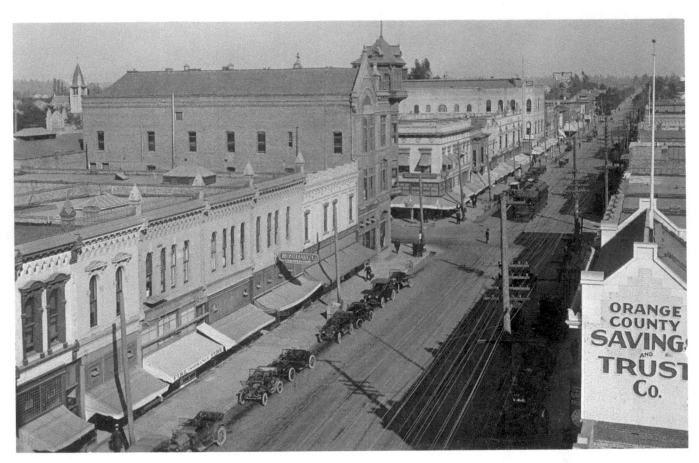

Powering electric railcars, the overhead lines running along Fourth and Main in Santa Ana had become a familiar sight to local by 1910. Whereas a trip to Los Angeles had once been an unpleasant, daylong ordeal, it was now entirely feasible to spend a few hours shopping in the big city and make it home for dinner. Each plushly appointed Red Car seated 57 comfortably on leather-upholstered seats and included a restroom and an ice water tank.

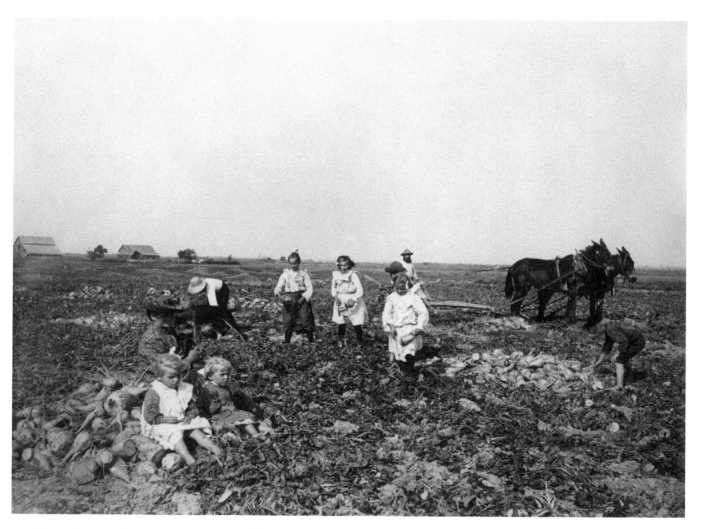

Harvesting sugar beets in the early years of the twentieth century was a labor-intensive operation that often involved the whole family, as the Jacob Kozina family demonstrates here in 1910. After the father pulls the beets out of the ground with a horse-drawn plow, his daughters cut off the leaves, and his sons stack them for pick-up. Even the family dog appears to be helping.

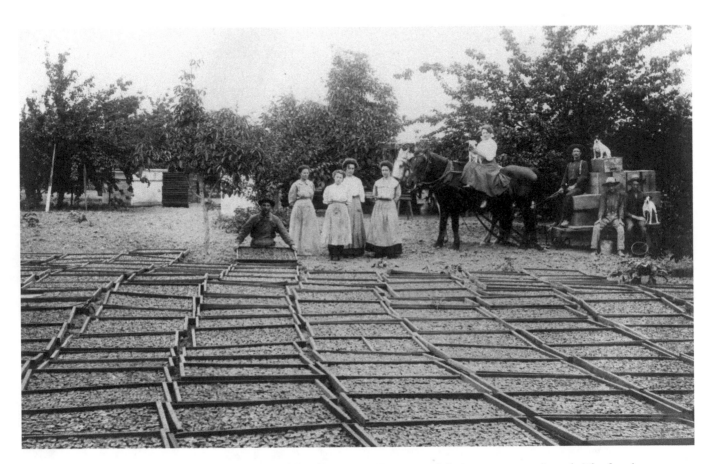

The bulk of Orange County's apricot crop was dried for shipment to Europe, and drying was women's work. The female workers of the George Fox Ranch in Tustin are shown here at center in 1910. Halved, pitted fruit was spread out on redwood trays over a pit of powdered sulfur for preservation, then left to dry under cardboard tenting for three to seven days. Typical pay was about 60 cents a day.

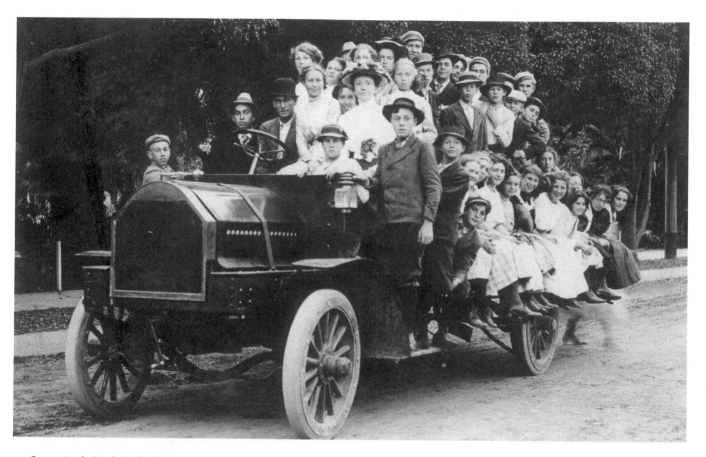

Santa Ana's Birch Park, shown here in May of 1910, was named for A. W. Birch of Illinois, who, like many before him, came to Southern California for the reputed health benefits of the mild climate, and ultimately built a large and successful farm. Today tiny Birch Park, largely hidden behind a senior center, is all that remains of the 80-acre farm that once covered much of what would become the city of Santa Ana.

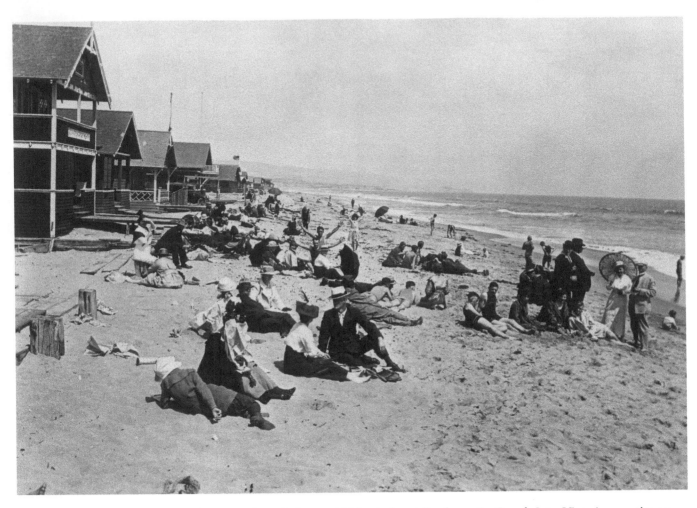

Looking much like a reenactment of Georges Seurat's famous 1884 painting *A Sunday on La Grande Jatte,* Victorian vacationers and day-trippers lounge fully clothed on Newport Beach in the early part of the twentieth century. Since then the attire has changed drastically, but Newport Beach still attracts hordes of weekend visitors—and the attendant traffic jams.

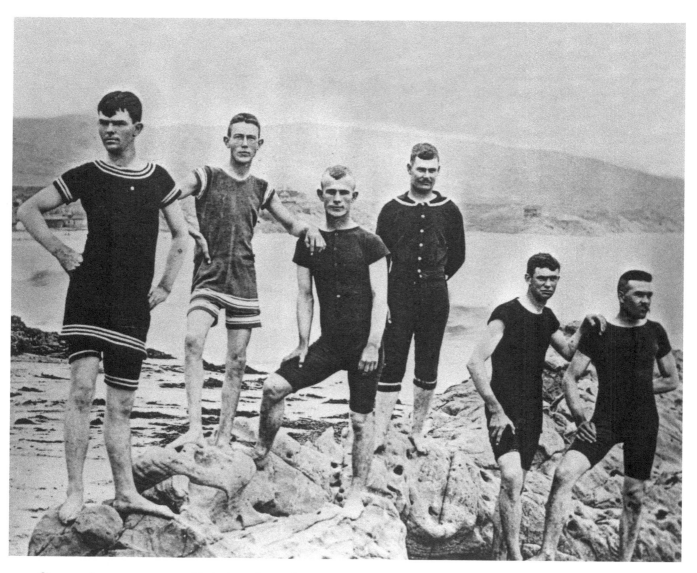

Six strapping young men model the latest in manly swim togs on Laguna Beach in 1912. Despite the bohemian artist colony growing in the city, Victorian mores still prevailed on the beach. The American Association of Park Superintendents' rules of the era forbade suits from exposing the chest below a line level with the armpits. In 1929 a Laguna Beach swimmer was arrested and charged with indecent exposure after scandalously doffing his shirt.

In 1913 much of Orange County suffered through a devastating cold snap that destroyed, by some accounts, as much as 60 percent of the year's orange crop, and turned the fountain on Orange's Plaza into an ice sculpture. Since many local resident had never seen icicles, the frozen fountain provided a bright spot in an otherwise tragic time.

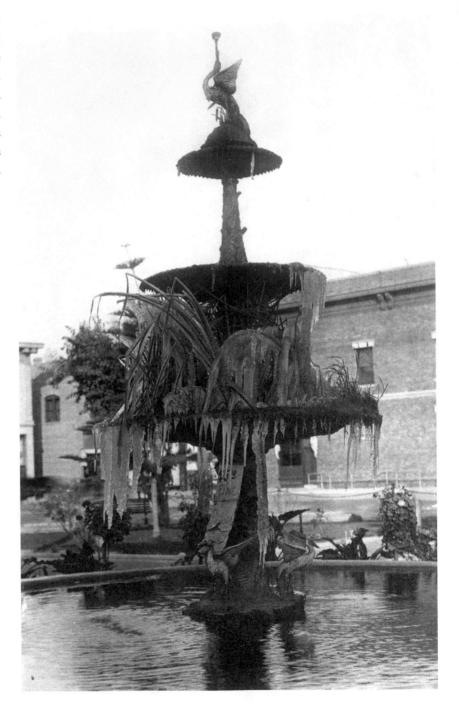

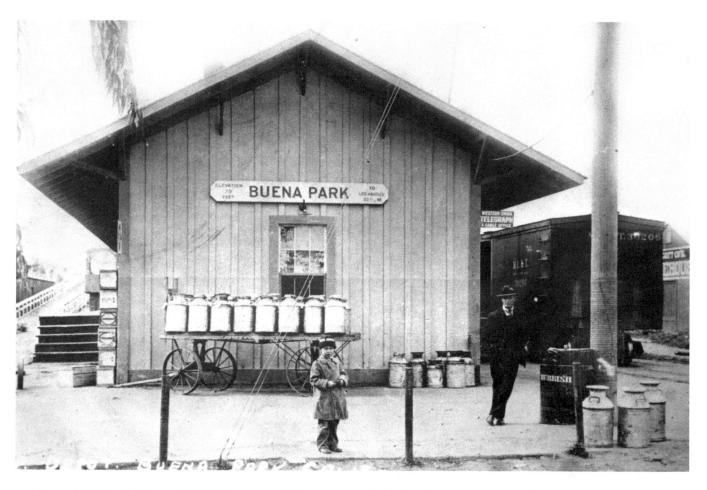

Buena Park founder James A. Whitaker centered the town around this Southern Pacific Railroad Depot only after the Santa Fe Railroad reneged on a promise to build him a depot a mile north. Show in 1914, the station was the hub of commerce for early settlers, sandwiched between a beet dump on one side and warehouses on the other. The little chap in front of the depot has been identified as six-year-old Percy Owens.

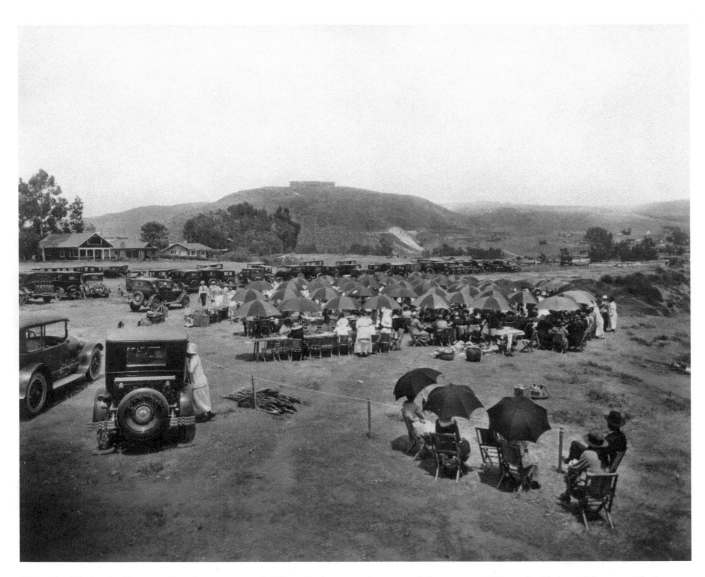

The valuable land of Laguna Beach never stayed fallow for long, as the turn-of-the-century Women's Club could attest. Their original hall was seized by the city and torn down for a new City Hall, and their picnic grounds atop Victor Hugo Point, shown here in 1915, were lost to Victor Hugo Restaurant. The site is currently the home of Las Brisas Restaurant, whose patio diners enjoy one of the finest views in all of Southern California.

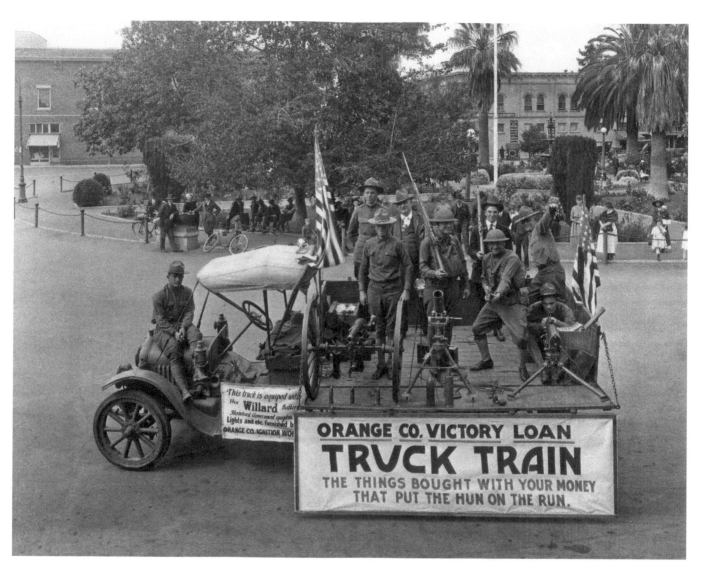

The Plaza in the city of Orange has always played a central role in the life of its residents. During World War I it served as backdrop to four Liberty Loan campaigns (one of which featured teenage silent-film star Mary Miles Minter) and the Victory Loan campaign of April 21 through May 10, 1919. In this photo, a smattering of observers has gathered to watch preparations for a "truck train" in support of the latter fund-raising program.

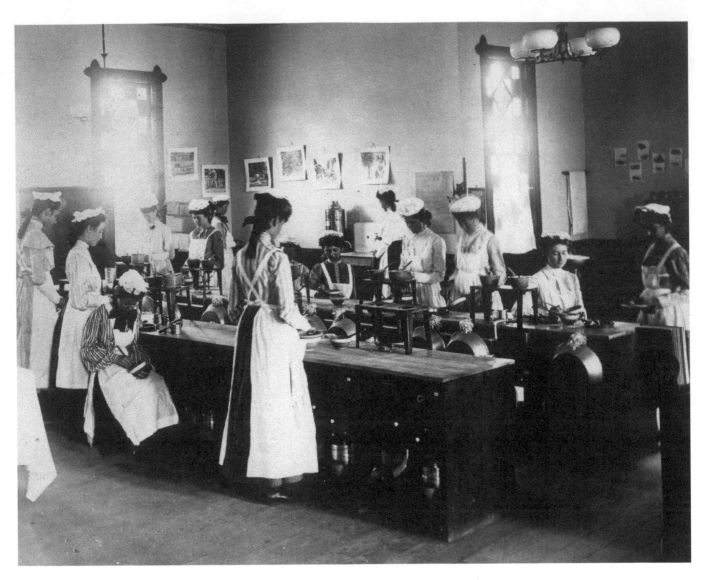

Santa Ana's first high school started life on the second floor of the Central Grammar School in 1889, but moved into its own new red-brick building on the corner of Ninth and Main in 1900. Constructed at a cost of $18,000, the building was demolished in the late 1940s to make way for a Buffum's Department Store. This 1919 photograph shows one of the first cooking classes offered to female students at Santa Ana High School.

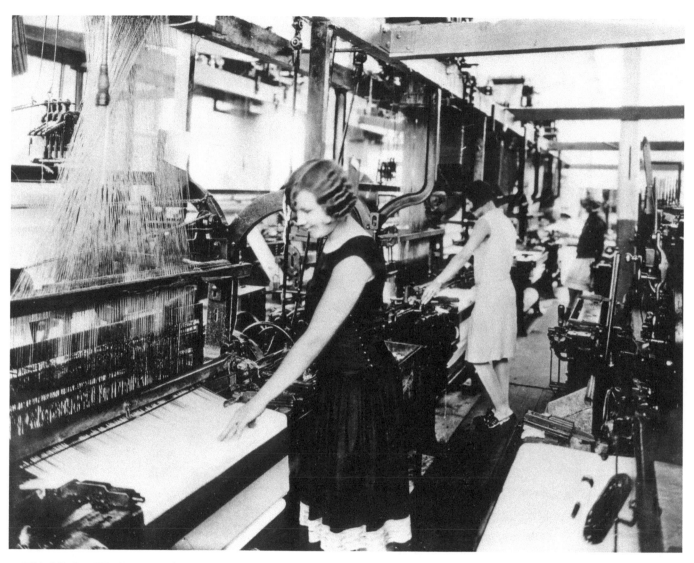

This Mission Woolen Manufacturing Company, located on the corner of Washington Avenue and Santiago Street in Santa Ana, opened in 1917. Manufacturing centered on army blankets and heavy woolen cloth for military overcoats. These fashionable young ladies were among the company's 75 employees doing their part for the war effort. Post-World War I production focused on lap robes and lighter-weight wools used in the manufacture of menswear.

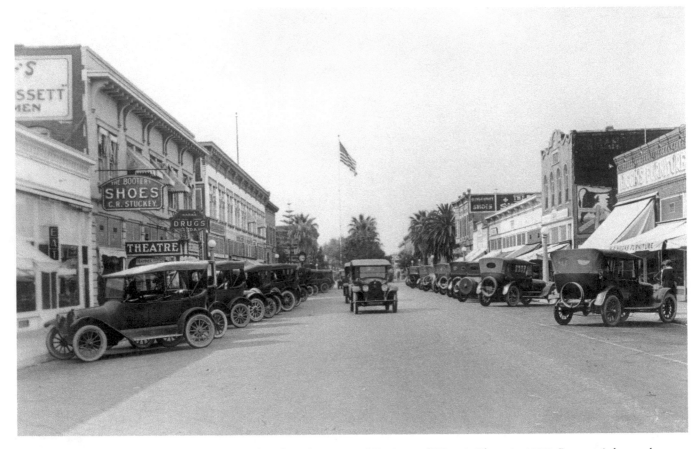

The Old Towne area of the city of Orange was listed on the National Register of Historic Places in 1997. Because it has such a high concentration of historic buildings and has retained a small-town look, downtown Orange is frequently used as a location for television shows and movies, such as the Tom Hanks-directed 1996 film *That Thing You Do!* This is a shot of South Glassell in the 1920s.

Trials and Tribulations

(1920–1945)

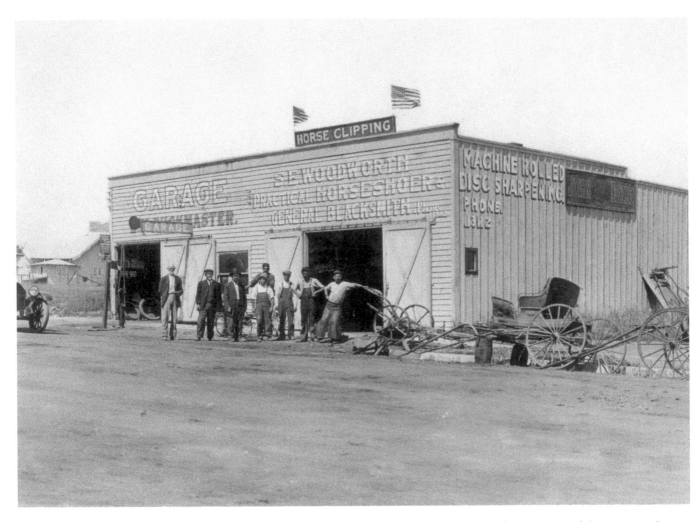

This multi-purpose building was located in Yorba Linda in the 1920s. Yorba Linda, in the northeast corner of the county, is best known as the birthplace of Richard Nixon, who reconstructed childhood home is now part of the Richard Nixon Library and Museum. In 2005, CNN listed Yorba Linda as no. 21 among the best places in the United States to live.

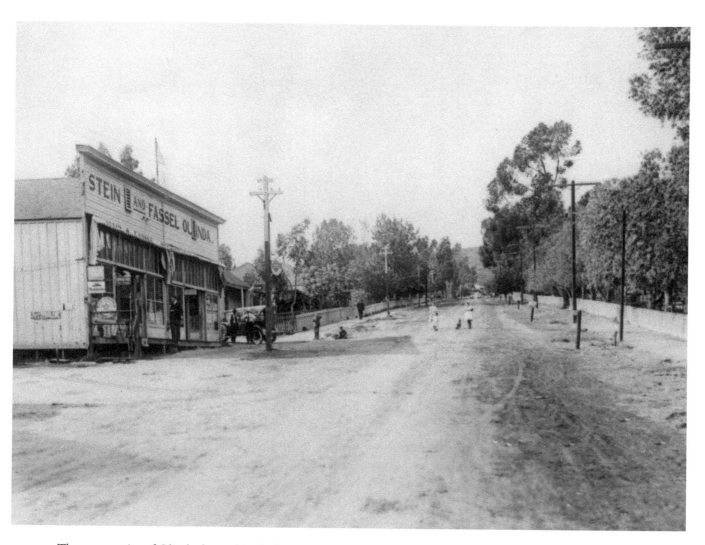

The community of Olinda, located in Carbon Canyon, was once considered prime agricultural land. That is, until oil was discovered in the late 1800s. Pastures quickly gave way to oil derricks, and Olinda, shown here in 1920, was a wealthy little boom town until the 1940s, when the fields began to shut down. In 1917, Olinda merged with the village of Randolph and incorporated as Brea, Spanish for "tar."

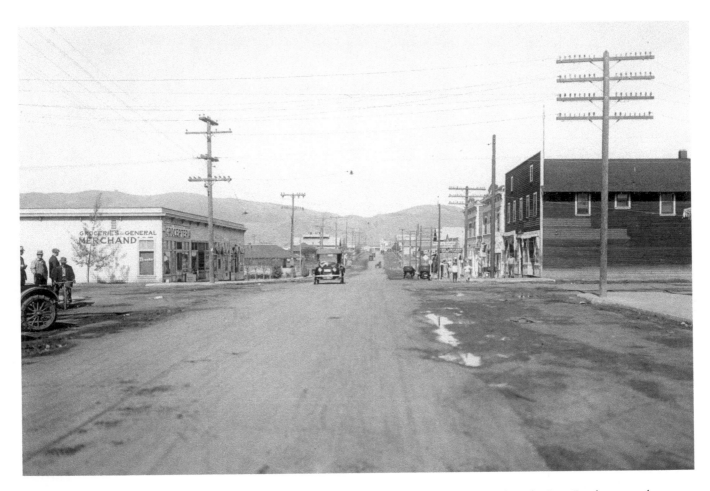

The biggest thing to happen to Brea since the discovery of oil took place on October 31, 1924, at the Brea Bowl, a natural amphitheater owned by Union Oil that has long since been covered over by housing tracts. That day, future Baseball Hall of Famers Walter Johnson and Babe Ruth faced each other in an exhibition game before 5,000 ecstatic fans. A half-day holiday was declared in three towns, and 100 extra officers were needed to police the grounds.

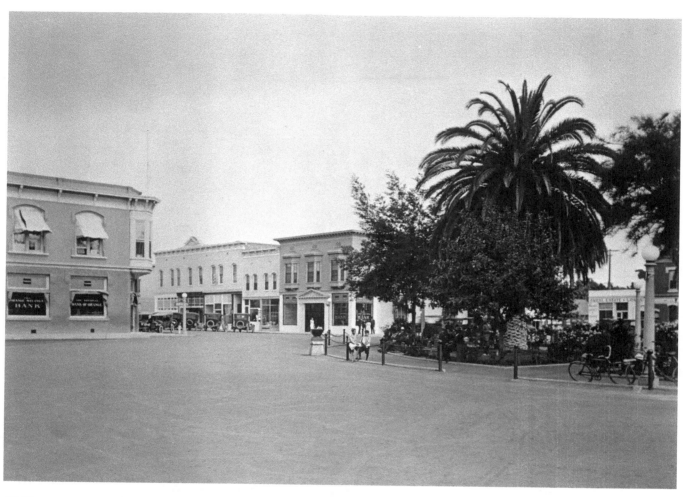

Unlike most cities in the congested northern half of the county, the city of Orange still has an identifiable, central downtown area. Shown here in the 1920s, the Plaza's shaded grassy areas, sidewalks, and famous fountain encourage strolling and social gatherings, while the historically significant architecture ringing the park bolsters civic pride. The Plaza is considered Orange County's oldest dedicated parkland.

This gracious fountain stood in the central Plaza of Orange from 1887 to 1937. The $585 needed to finance its installation was raised by the Orange Women's Temperance Union, largely through the production of an original satiric play called *The Plaza: A Local Drama in Five Acts*, written and acted by townspeople. After several decades in storage, the fountain was fully restored in 1981 and currently stands behind the Orange Public Library.

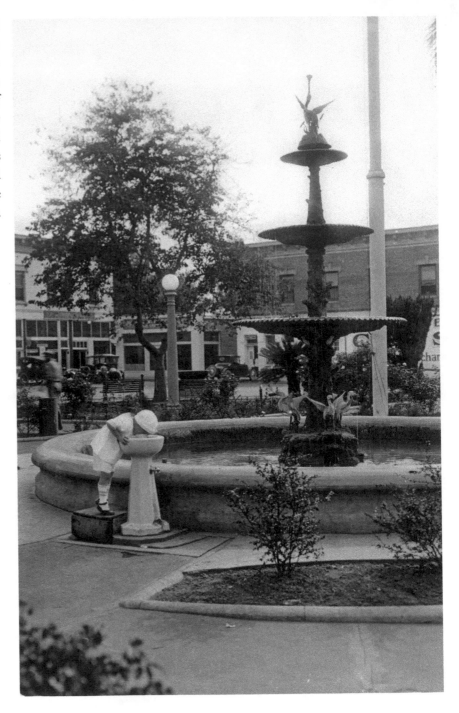

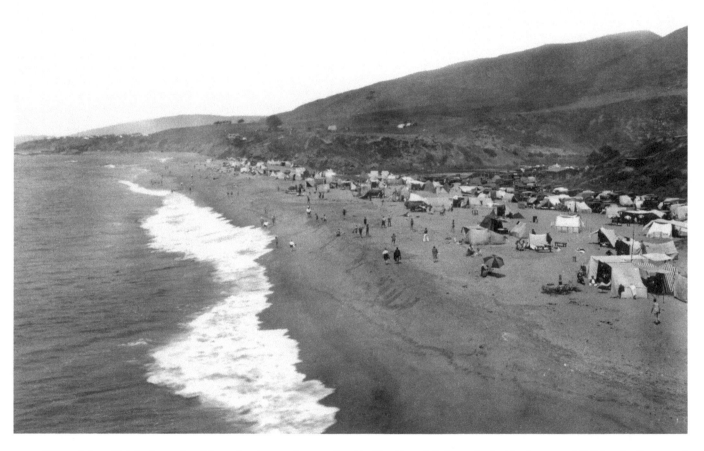

When Mary Pickford cut the ribbon for the newly complete Pacific Coast Highway in 1928, the rest of California discovered the previously hidden gem that was Laguna, and the days of camping free on the beach were gone. Tents soon gave way to beach cottages, and these in turn were eventually replaced by the multi-million-dollar homes that now dot the bare cliffs seen behind these campers on Aliso Beach around 1922.

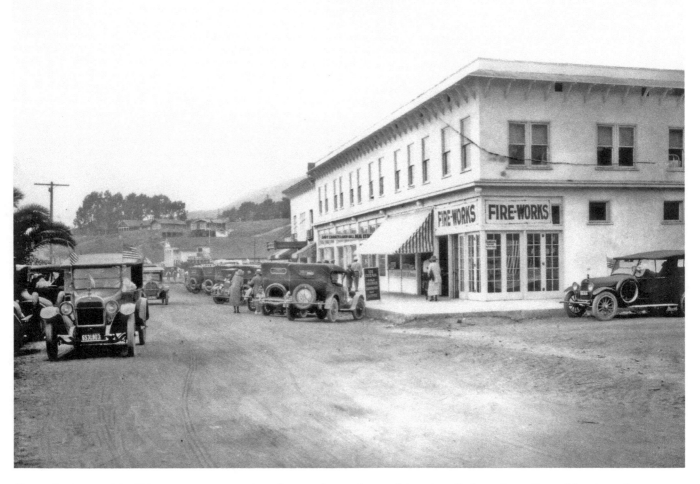

Fireworks, invented in China 2,000 years ago, have been an integral part of American Independence Day celebrations since 1777. This temporary fireworks store at the corner of Pacific Coast Highway and Ocean Avenue in Laguna Beach was doing bang-up business in the 1920s. Though the city was still sparsely populated at the time, the parking lot was full and patrons double-parked to make their purchases.

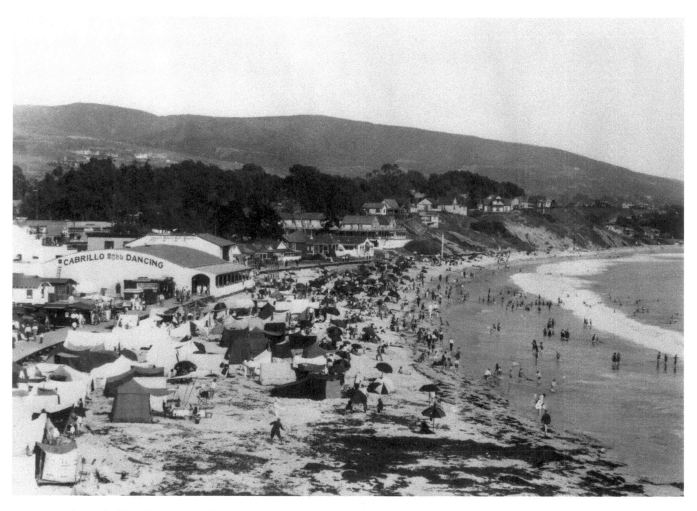

In 1926 the Cabrillo Ballroom, at left, opened on Laguna's main beach and was *the* place to be through the Roaring Twenties for dancing and big-name jazz bands. Before finding fame as an actor, Fred MacMurray played saxophone there, and Mickey Rooney was known to sit in on drums. By 1940, the good times were over and the ballroom was converted into a bowling alley and pool hall. The building was torn down in the late 1950s.

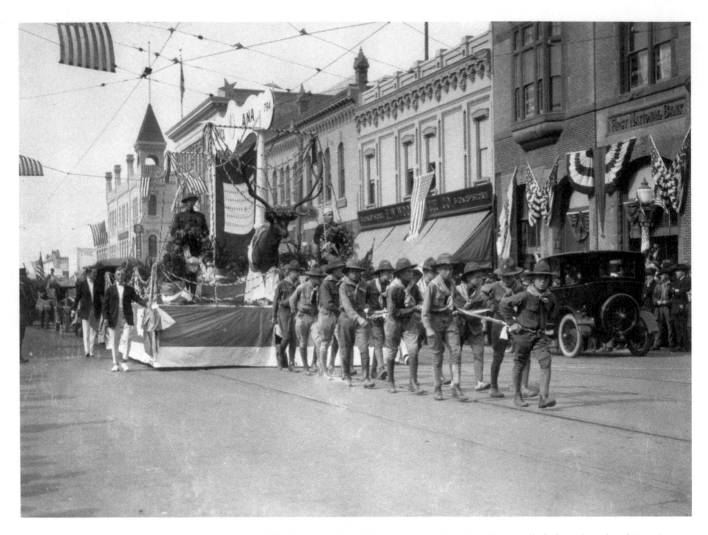

Employing a low-tech form of locomotion, the Elks Float in this 1920s Armistice Day Parade is pulled along by a local Boy Scout troop. Downtown Santa Ana businesses, including F. W. Woolworth and the First National Bank, both visible at right, are draped in bunting to celebrate the anniversary of the end of World War I. Armistice Day was later renamed Veteran's Day.

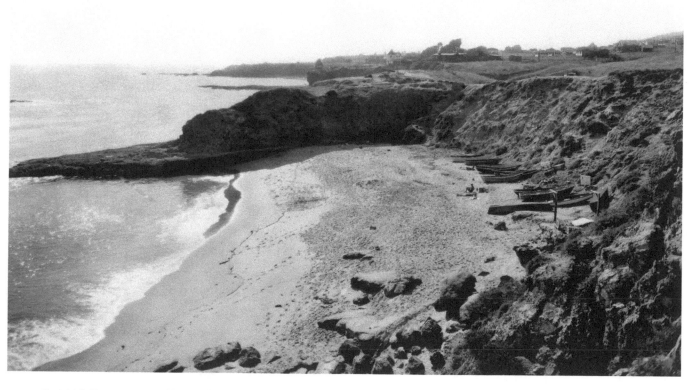

By 1924, Laguna was still sparsely populated and remote, and fishing opportunities at its many beaches were the main draw. It was said that lobster and abalone could practically be plucked from the beach. Today, Diver's Cove is a popular scuba-diving spot with generally calm surf conditions and an offshore reef that teems with colorful sea life such as octopus, spiny cowries, anemones, bat rays, and vivid orange garibaldis.

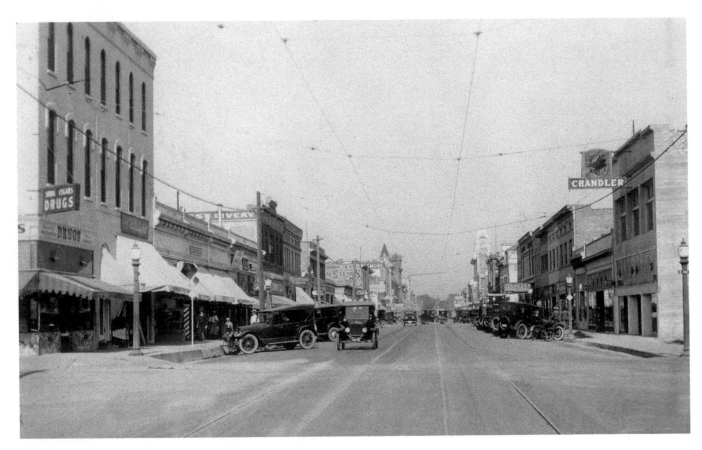

In Santa Ana the view down Fourth Street from Ross is still recognizable from 1925. The Clausen block, right foreground, is intact, and the Spurgeon can still be seen off in the distance. While the block across the street has been replaced by the modern Federal Building, a vibrant historical mural inside links it to the past. A railway spike motif on the surrounding walls pays homage to the tracks that once divided the street.

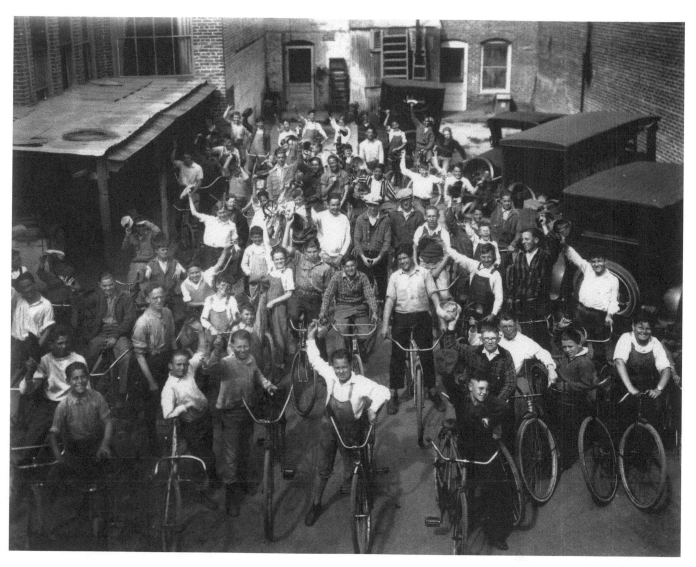

Early-nineteenth-century bicycle prototypes, known as velocipedes, were uncomfortable and difficult to ride, but the invention of the modern bicycle in the latter part of the century sparked a biking fad, as demonstrated by this crowd of boys outside a Santa Ana fix-it shop in the 1920s. The sunny Southern California weather makes bicycle riding a feasible transportation option year-round for environmentally conscious adults as well as fun-loving kids.

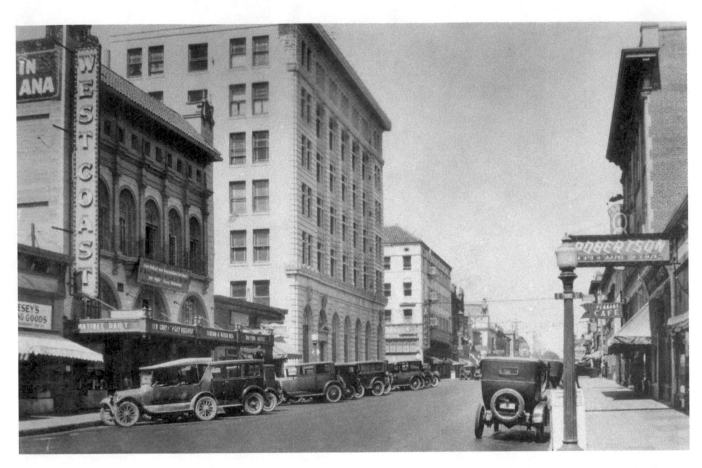

The Boller Brothers-designed Fox West Coast Theater opened on Main Street in Santa Ana in 1924 and showcased vaudeville acts direct from the Orpheum in Los Angeles and silent films such as Will Rogers's *Two Wagons, Both Covered*, which was one of the opening attractions. The theater seated more than 1,300 people and featured state-of-the-art cooling and lighting systems, opulent Art Moderne scrollwork, Arts and Crafts stained glass, and a Wurlitzer organ.

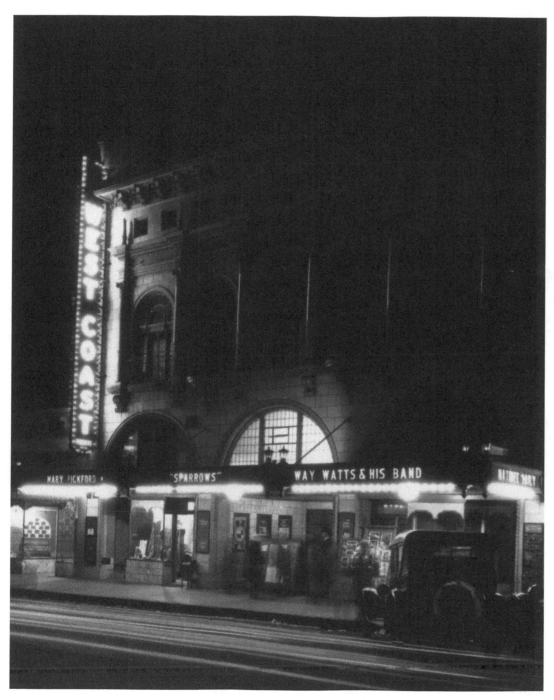

Mary Pickford's silent movie *Sparrows* was the featured attraction in this 1926 night shot of the West Coast Theater. The theater was placed on the National Register of Historic Places in 1982 but quickly fell into disrepair and was closed shortly thereafter. In 1991, the building was restored and converted to a Hispanic church, Tabernaculo Cristiano.

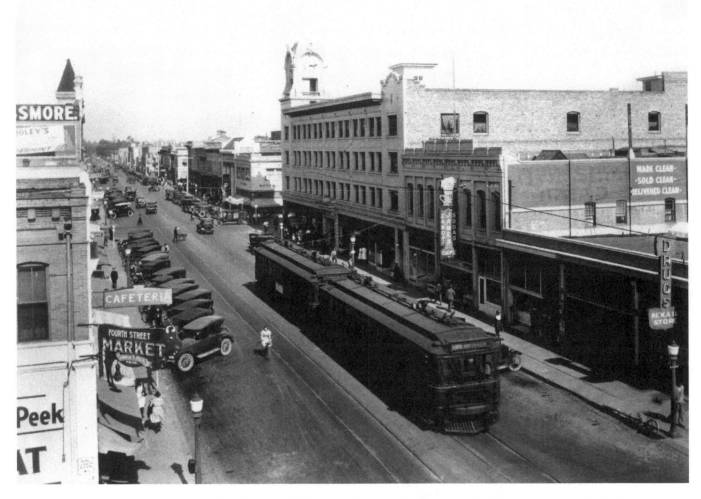

In this late-1920s photograph, the Pacific Electric Red Car passes between the Spurgeon Building, at center, and the Rossmore Hotel, at left, on Fourth Street in Santa Ana, while traveling along its route between Santa Ana and Los Angeles. The Pacific Electric line eventually linked more than 150 Southern California communities and was the primary means of intercounty transportation for four and a half decades.

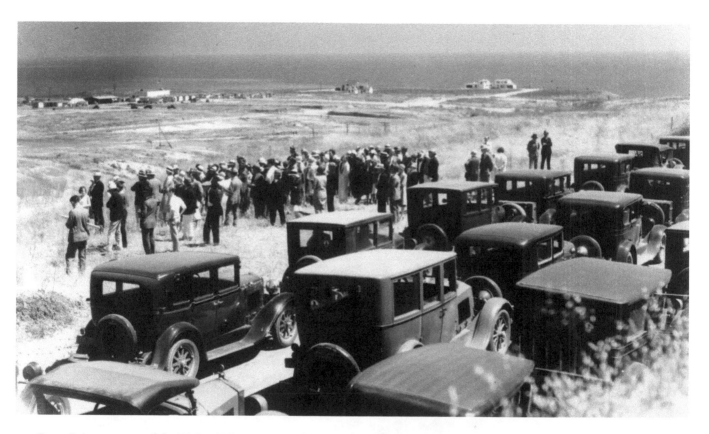

Dana Point was named for Richard Henry Dana, whose 1840 travelogue referred to the rugged coastline as "the only romantic spot in California." Several unsuccessful attempts were made in the 1920s to promote Dana Points, including the 1927 grand opening of a subdivision planned by Hollywoodland builder Sidney Woodruff. It wasn't until the late 1950s, when the San Diego Freeway was extended through southern Orange County, that Dana Point was finally opened to new residents.

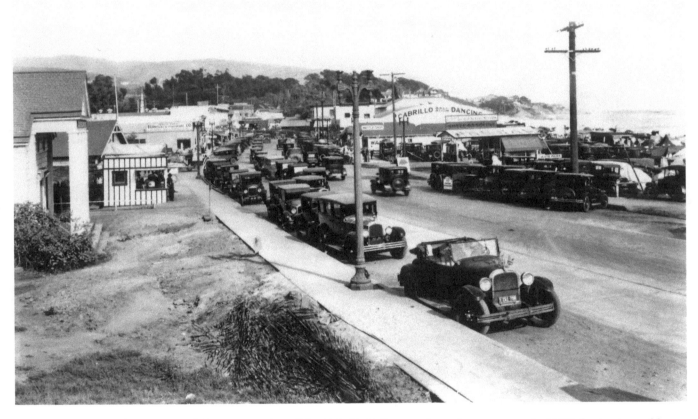

Many Laguna Beach locals opposed the construction of the Cabrillo Ballroom, shown here at center in 1927, fearing it would lead to hot dog vendors and cheap-souvenir stands, essentially turning the rustic artist colony into a second-rate Coney Island. The townsfolk needn't have worried: the pristine sands where the dance hall one stood have been restored, and dining and shopping opportunities today are definitely not of the cheap variety!

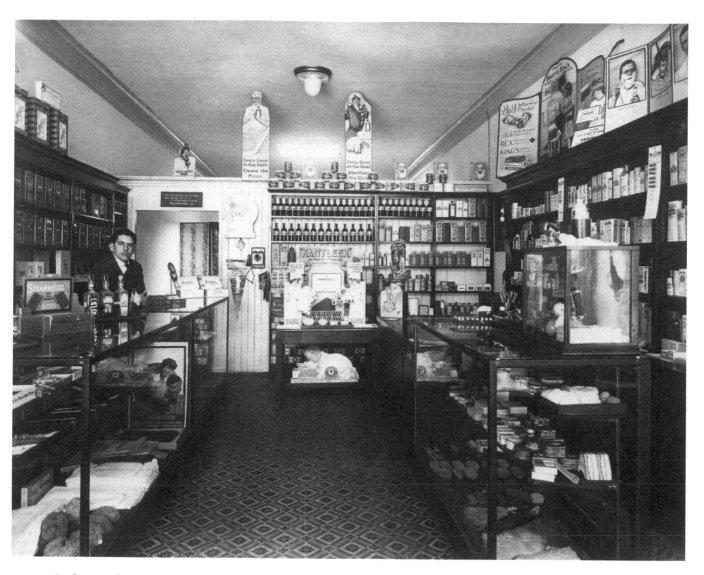

In Orange County as elsewhere, the period between the world wars was a golden age of hucksterism. In this 1929 image, a shop clerk in Santa Ana sits surrounded by dubious potions and lotions promising to cure corns, clean pores, and sterilize skin. Ironically, many of the early-twentieth-century buildings that housed these purveyors of empty promises still stand, but their occupants are now twenty-first-century lawyers, ready and willing to sue over false advertising

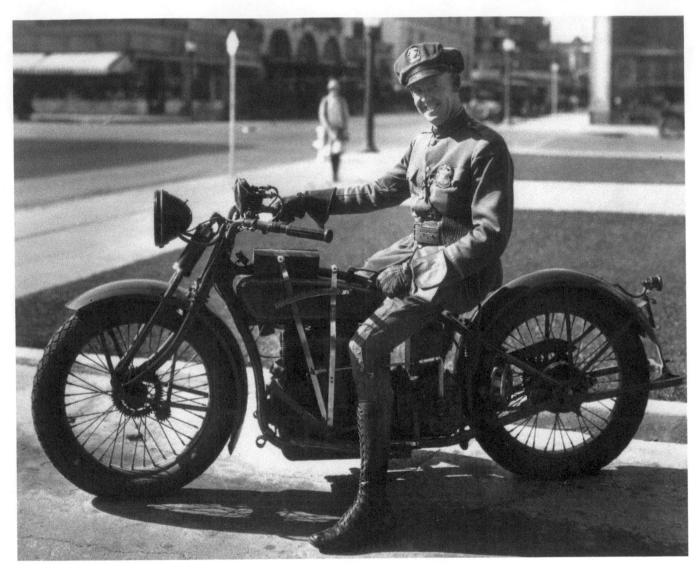

When Santa Ana's police department formed in the 1880s, horseback patrols enforced laws against leaving park gates open and keeping pigeons within city limits. By the 1930s, when this photo was taken, the mode of transportation had changed, and the issues confronting residents had grown in scope. Between the Depression, the 1933 earthquake, the end of the Prohibition, and the 1938 flood, Santa Ana's finest had their hands full maintaining law and order.

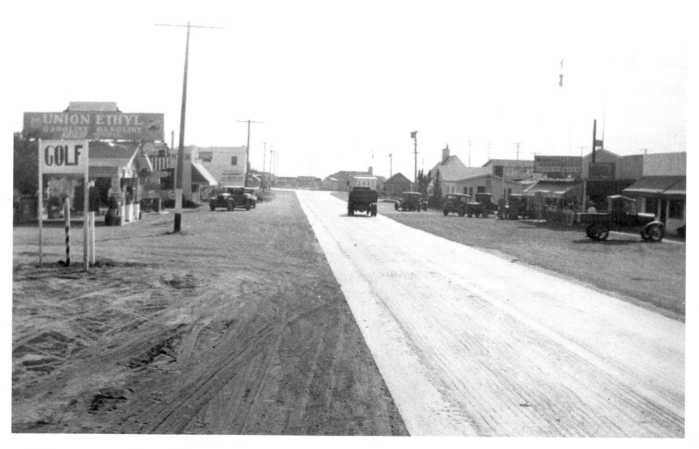

For better or worse, the 1956 Interstate Highway Act would transform Orange County. The sleepy hamlet of Capistrano Beach, shown here in 1930, was but one of many isolated towns along the coast before completion of the 5 Freeway, which would run the length of the state. In 1989, Capistrano Beach and neighboring Laguna Niguel voted to join newly incorporated Dana Point and today have a healthy combined population of 35,000.

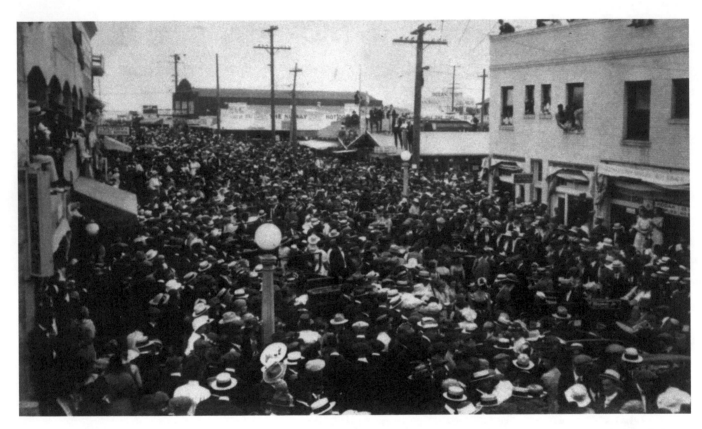

Modern rush-hour traffic on the 5 Freeway pales in comparison to this scene of a 1930s-era event in Newport Beach. People hang from windows and stand on rooftops to get a better view of the proceedings below, and others are trapped in their cars by the impenetrable mass of humanity clogging the streets. The photograph was likely taken from the Balboa Pavilion.

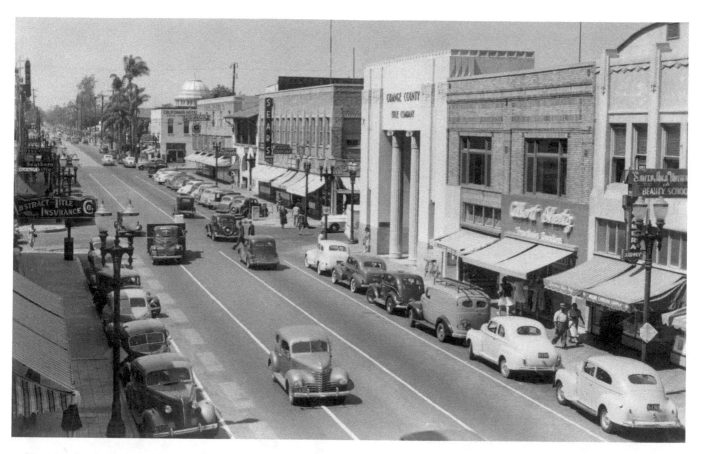

In 1931, Santa Ana's Orange County Title Company moved into its new, gleaming white, Zigzag Moderne headquarters, shown at right in this photo, directly across from the company's chief competitor, the Orange County Abstract Title and Insurance Company. The two later merged to form First American Title Insurance Company, possessors of an extensive photographic archive from which many of the images in this book were taken.

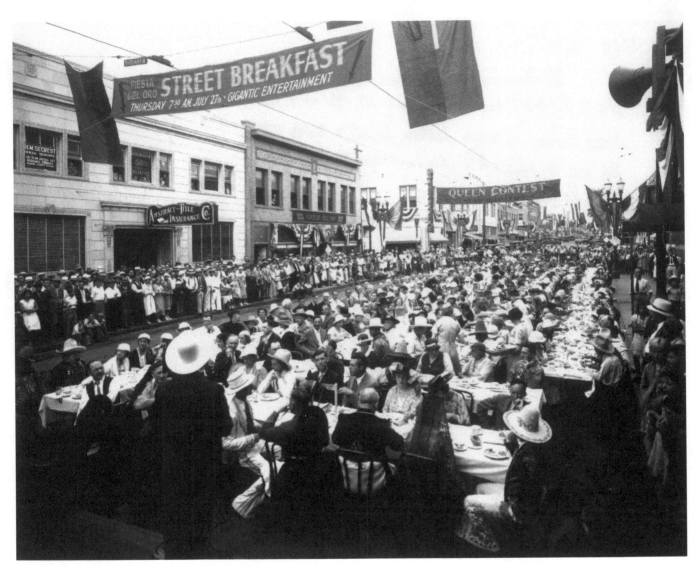

The Santa Ana Breakfast Club, founded in 1925, was an informal civic group that became known for its al fresco breakfasts. From these humble beginnings arose the three-day Fiesta del Oro of 1933, which kicked off with this standing-room-only street breakfast at 7:30 A.M. on a closed-off block of North Main Street, between Fourth and Fifth streets. Honorees at the event included Fiesta Queen Margaret Sawyer and James B. Utt, future congressman.

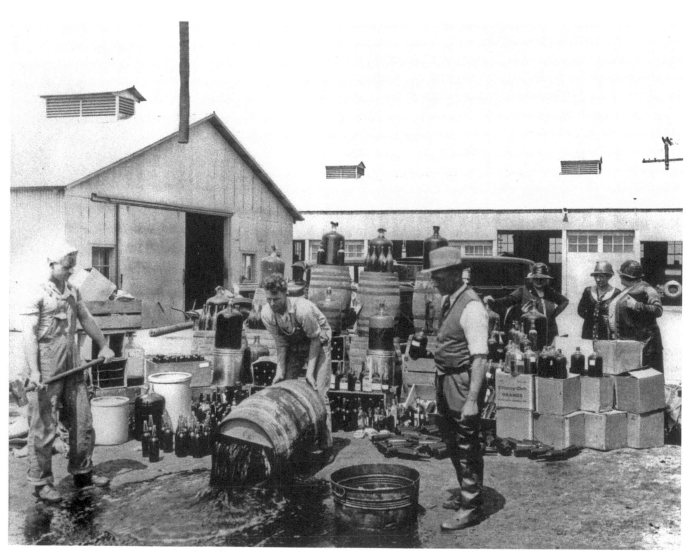

The Women's Christian Temperance Union, founded in Fredonia, New York, in 1873, was instrumental in the passage of the Eighteenth Amendment, ushering in the era of Prohibition. The local Santa Ana chapter of the WCTU was very active and succeeded in making Santa Ana a dry town 17 years prior to the national legislation. The three ladies at right in this 1933 photograph of liquor being dumped were likely members of the organization.

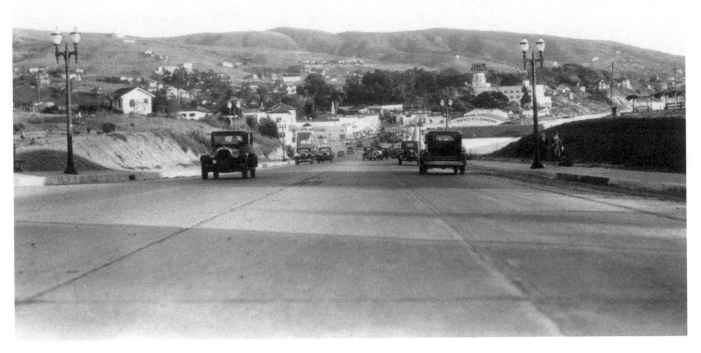

This shot looking south on the Pacific Coast Highway shows Laguna Beach at the height of the Great Depression. It was during this time that local artists inaugurated the Festival of Arts as a means of generating income. The festival has since grown to encompass three large art shows and the Pageant of the Masters, the tableaux-vivant production that shows nightly every summer in the Irvine Bowl, a natural amphitheater in the Laguna hills.

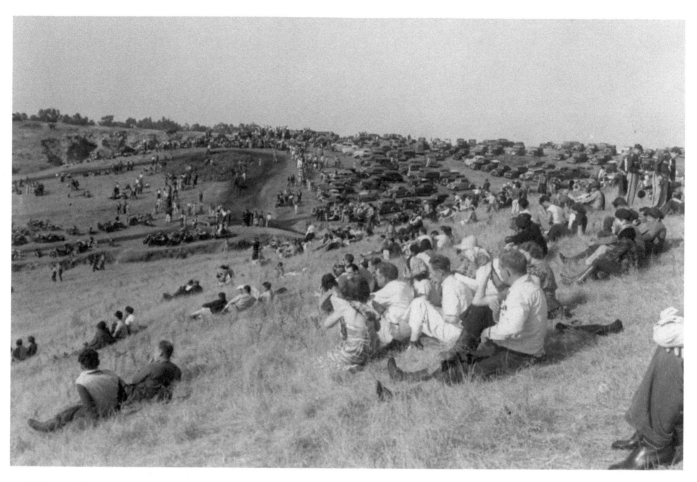

Motorcycle racing was an inexpensive entertainment during the Great Depression years, and races held in the hills surrounding what would become Costa Mesa drew large crowds, as in this 1930s photograph shows. These unofficial gatherings were a precursor to the current Costa Mesa Speedway races, held every Saturday night from April through September since 1969 at the Orange County Fairgrounds.

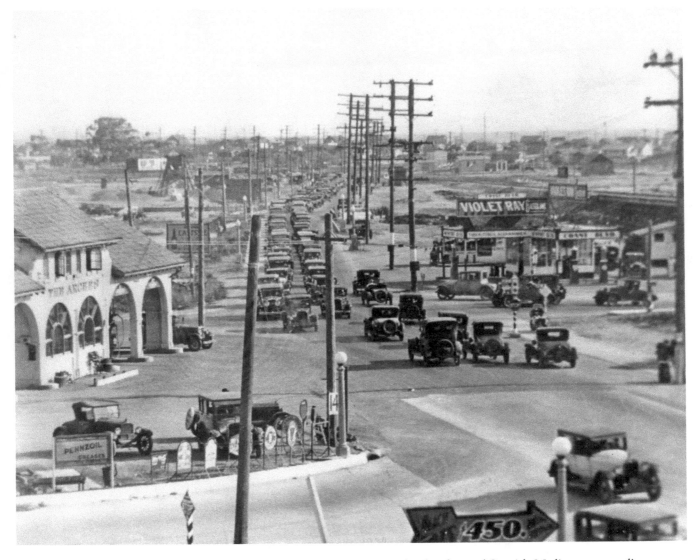

The Arches, at left in this 1930s photo, was a service station-restaurant combo that featured Spanish-Mediterranean styling complete with arches—hence the name—and that catered to traffic on the newly completed portion of the Pacific Coast Highway that ran between Newport Beach and Laguna. The restaurant eventually acquired a celebrity clientele that included Humphrey Bogart, John Wayne, and the Rat Pack.

During Prohibition, Laguna Beach police officers, such as this one, had their hands full when the long, rugged coastline became a hotbed of bootlegging activity. Suppliers would anchor three miles off the coast at night to wait for fishing boats, which would ferry the moonshine ashore in gunny sacks. Lookouts on the cliffs kept watch for "revenuers." Locals were sometimes pleasantly surprised to find a stray bottle or two washed up on the beach in the morning.

In addition to loss of life, the Long Beach Quake, as it came to be known, caused millions of dollars in property damage, primarily to coastal communities such as Huntington Beach, show here, where liquefaction shook oil rigs and telephone poles out of the ground and ruptured water mains, leaving residents without utilities for days. This photograph was taken east of Huntington Beach, near the Coast Highway.

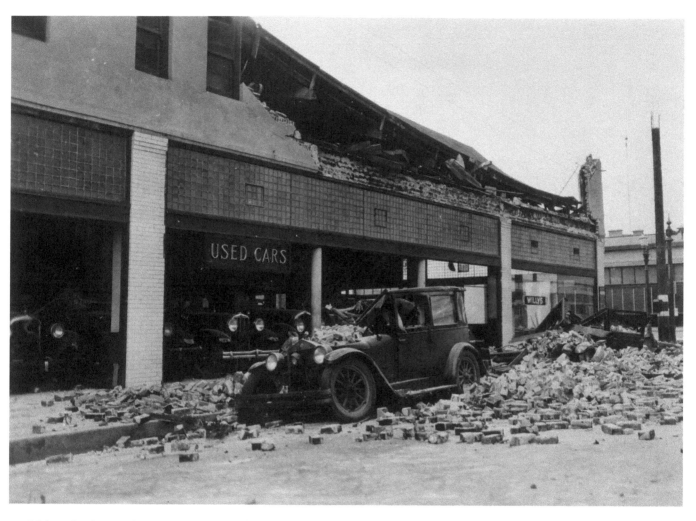

Of the inland cities, Santa Ana was particularly hard-hit by the 1933 earthquake, due to the large number of unreinforced brick buildings lining its downtown streets. This photo shows the damage to the Halcy Building at the corner of 5th and Bush. Scenes like this one led to the passage of the Field Act one month later, establishing rigorous building codes for public buildings that greatly reduced property damage and loss of life in subsequent quakes.

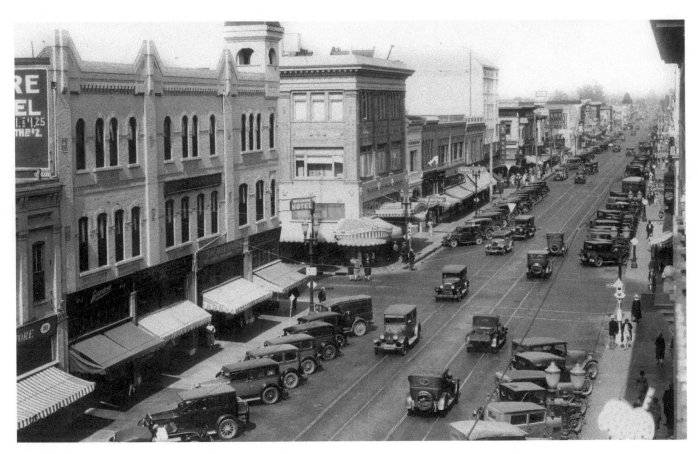

Seen here in 1930, the Rossmore Hotel, at left, would be the site of two of Santa Ana's three fatalities in the 1933 earthquake. On March 10, Jess and Yetta Ellison, a honeymooning couple from Oakland, were on their way to the hotel restaurant when they felt the tremors and ran outside, into the path of falling bricks. The restaurant itself sustained little damage.

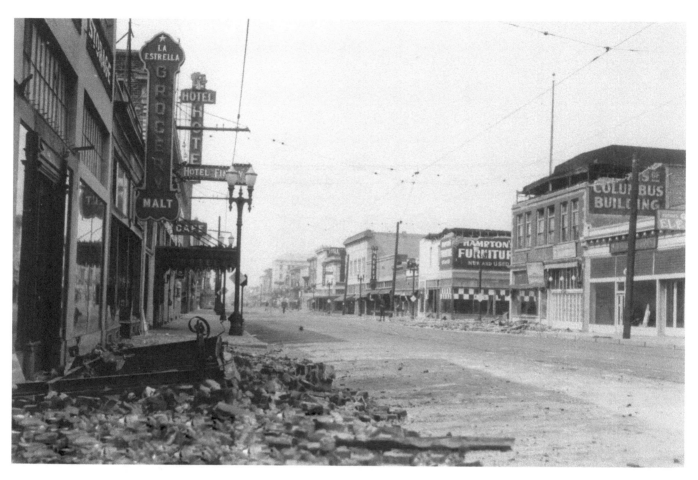

All over downtown Santa Ana, windows shattered and unreinforced buildings lost their facades in a shower of plaster dust and crumbling bricks. Earl Wilson Adamson was buried under the debris while walking along Fourth Street and became the city's third casualty. So many buildings were deemed unsafe and were subsequently demolished that the city's skyline was forever changed, the razed structures replaces by Art Moderne buildings that complied with stringent new codes.

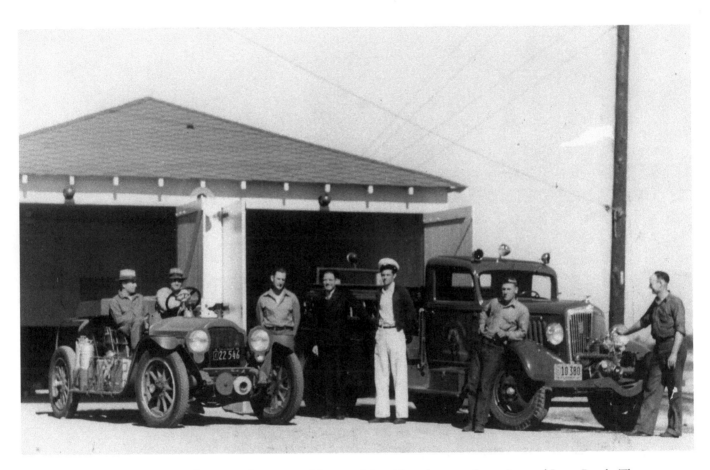

Midway City is an unincorporated community so named because it is midway between Santa Ana and Long Beach. The area has been fighting off annexation attempts almost since its inception, most recently by neighboring Huntington Beach and Westminster. Though fire protection today is provided by the county, in 1936 it was undertaken by this volunteer fire department, proudly posed with their equipment in front of their firehouse.

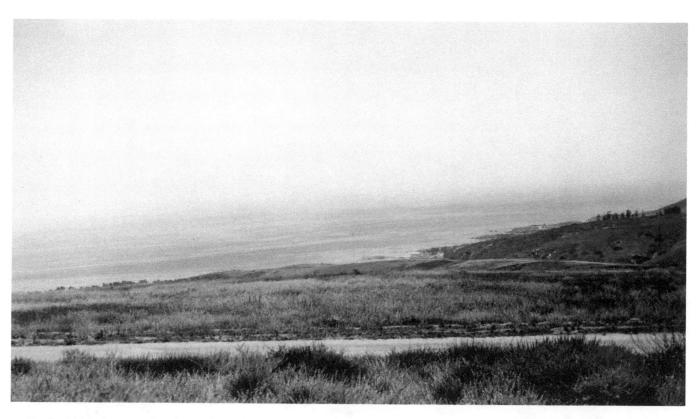

By the 1920s the rugged and varied coastline of Laguna Beach had been discovered by Hollywood to be the perfect stand-in for just about anywhere, and many movies were filmed there. An early Buster Keaton silent movie substituted Laguna for Italy; *The Life of Emile Zola*, winner of the 1937 Oscar for Best Picture, was set in France but filmed among Laguna's bluffs; and the 1942 Bette Davis flick *Now, Voyager* replaced multiple worldwide locales with Laguna sites.

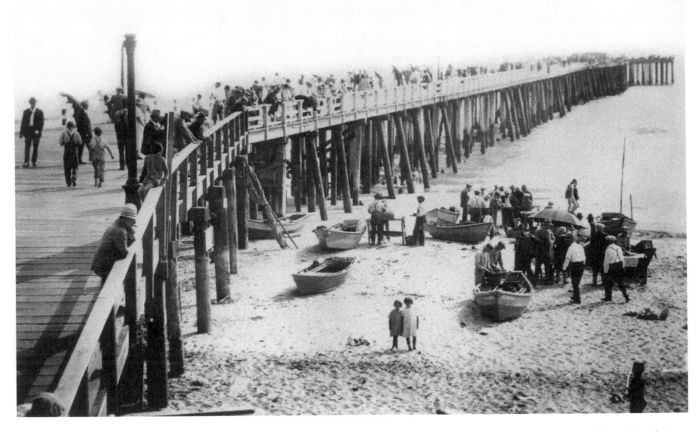

Newport's Dory Fleet is an institution that dates back to the construction of Newport Pier, then known as McFadden Wharf, in 1888. Named for he small, flat-bottomed boats they use, the dory fishermen still go out to sea every morning, returning to sell their catch to locals right on the beach, using their weather-beaten boats as sales counters. The practice originated as a way to eliminate the middleman and has evolved into a time-honored tradition.

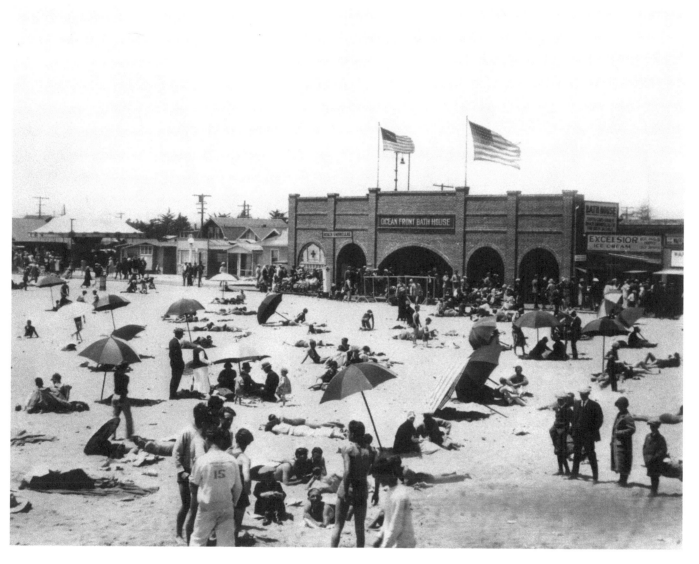

Bathhouses of the 1930s like this one on Balboa provided a safe alternative to swimming in the cold, rough waters of the Pacific Ocean, a task made even more difficult by the heavy, wool swimsuits of the era that tended to weigh an extra 20 pounds when wet. Orange County's coastal bathhouses typically offered a heated saltwater pool, swimsuit and beach-umbrella rentals, lockers and changing facilities, and a basic lunch menu.

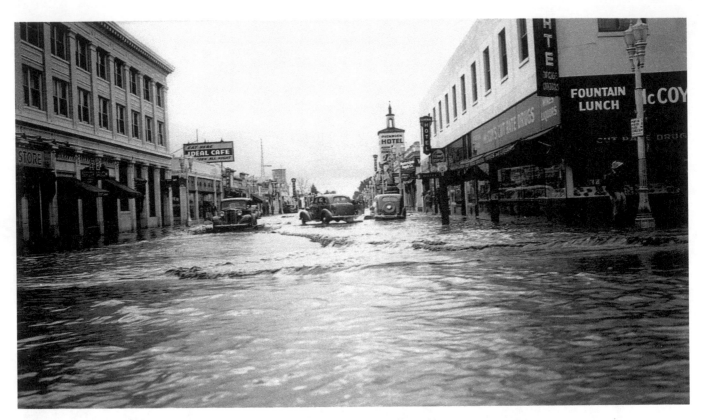

Ten days of heavy rain in February 1938 caused the Santa Ana River to overflow its banks, sweeping away the little town of Atwood and destroying nearly every bridge in Anaheim. Five minutes after the Anaheim fire department whistled a warning, a wall of water four feet deep crashed through homes, sweeping away vehicles, livestock, and barns. Moments later floodwaters hit downtown, filling basements and rising several feet into the first level of nearly every business establishment. State militia held looting to a minimum, placing the city on virtual lockdown till order could be restored.

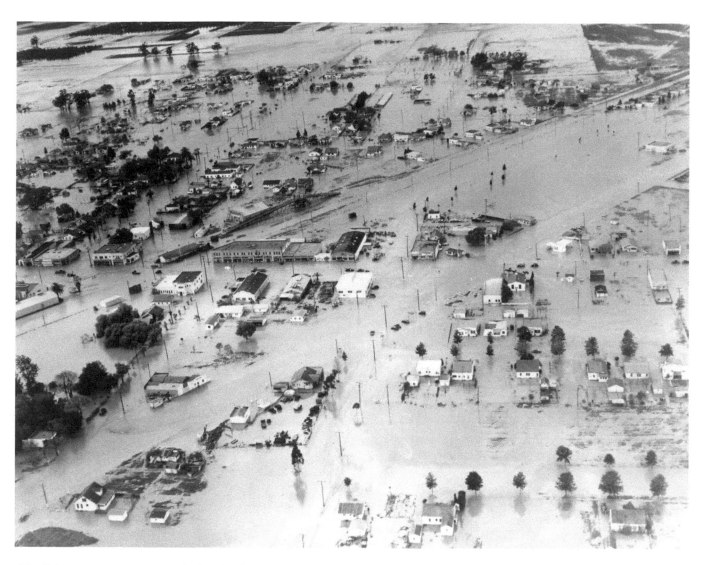

The February 1938 storms resulted in the Santa Ana River overflowing its banks and unleashing a torrent of water that devastated much of Orange County. This photograph shows Buena Park's downtown area underwater. The flood, the second to affect Buena Park in just over a decade, was the catalyst for the construction of citywide flood-control channels.

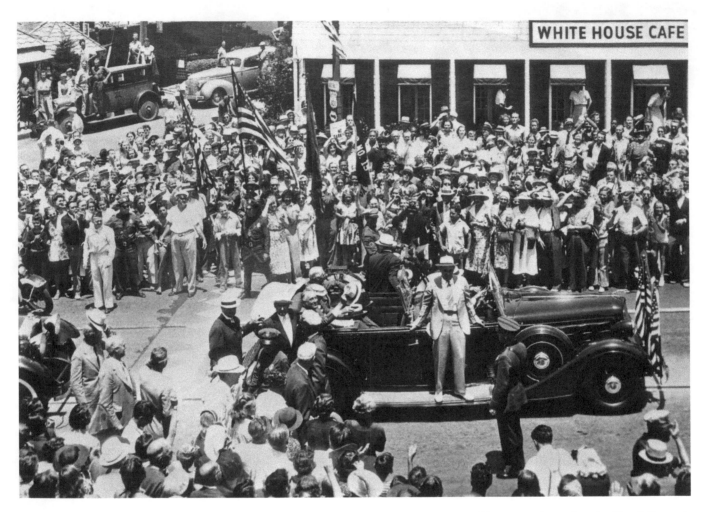

Following the flood of 1938, President Franklin D. Roosevelt toured the disaster areas and later signed into law the Flood Control Act of 1938, which authorized the construction of dams, levees, and dikes through the management of the U.S. Army Corps of Engineers. He is shown here in Laguna Beach, in front of the White House restaurant, which opened in 1918 and is still a popular nightspot, known for offering live music seven nights a week and for showcasing local art.

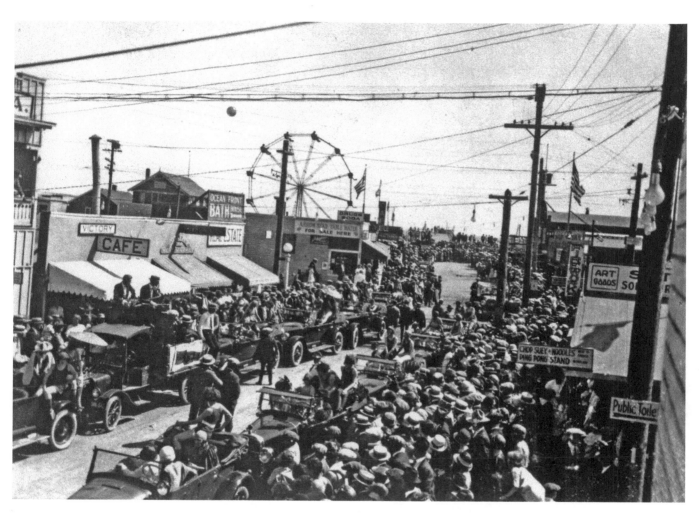

One of the earliest of Orange County's many tourist attractions was the family-owned-and-operated Fun Zone on Balboa, shown here in the late 1930s. Opened in 1936, the park featured such colorfully named rides as Punk Rack, Spill the Milk, and the Bird Cage Ferris Wheel. After a major refurbishing in 1986, the Fun Zone is still going strong and is currently owned by the Newport Harbor Nautical Museum.

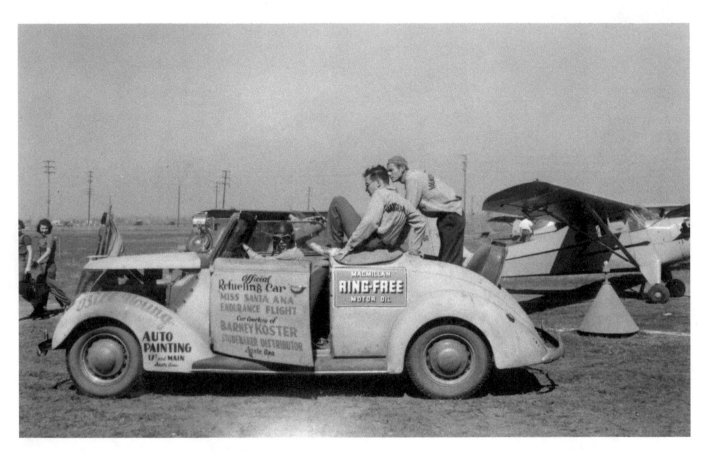

Shown here in 1939 is the support car for the Miss Santa Ana Endurance Flight. Santa Ana played a big role in early aviation history. In 1924 resident Eddie Martin built OC's first airport, the Eddie Martin Airport. Howard Hughes crashed into a Santa Ana beet field in 1935 after setting a speed record. And Douglas "Wrong Way" Corrigan, inspiration for the 1939 movie *The Flying Irishman,* settled in Santa Ana after his 1938 transatlantic flight.

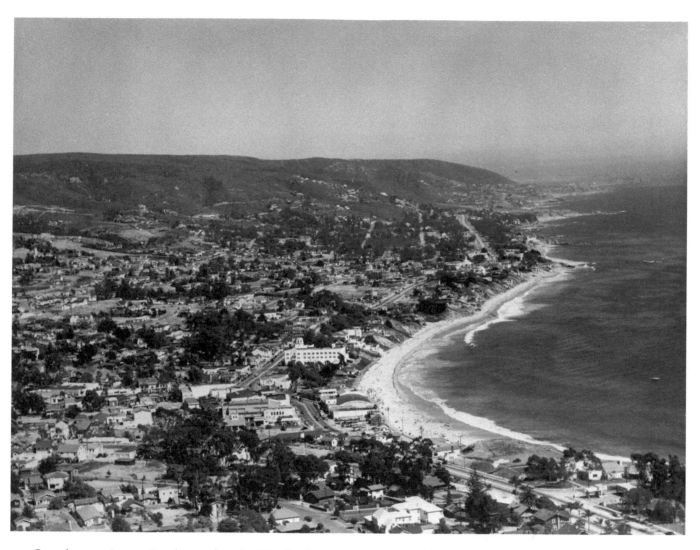

Over the years Laguna Beach, seen here in 1939, has been home to many celebrities, including Bette Davis, Judy Garland, and Rudolph Valentino. But the town's most famous resident is the Laguna Greeter, a Danish immigrant who arrived in 1940. For the next 33 years this eccentric character stood by the Coast Highway and welcomed all visitors to town with a booming "Hellooooo, How Are You?" A statue in his honor stands in front of the old Pottery Shack.

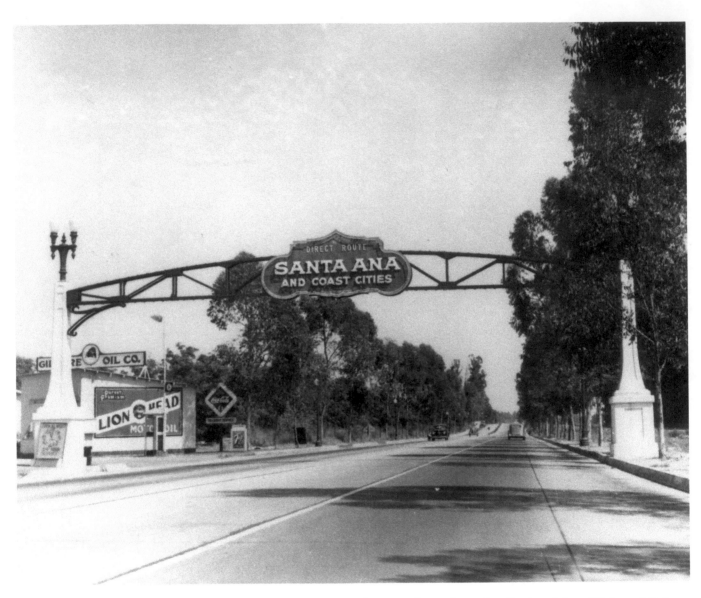

This sign, shown in 1940, once welcomed visitors to Santa Ana as they turned onto Santa Ana Boulevard from Highway 101 (now the 5 Freeway) on the northwest edge of town. Though the original sign is long gone, a near-exact replica was installed in 2007 on Main Street, identifying the Historic South Main Business District.

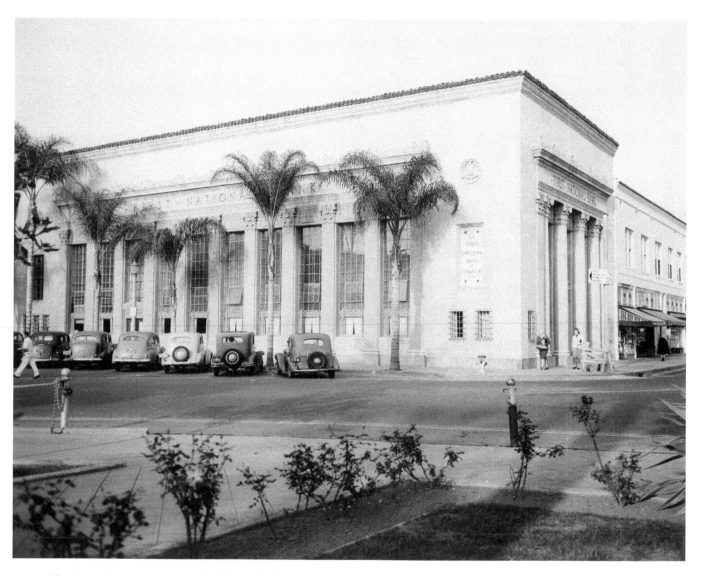

The Beaux Arts structure was built in 1923 by the architectural firm of Morgan, Walls, and Clements, designers of such Los Angeles icons as the Mayan, Belasco, and Wiltern theaters (all L.A. historic cultural monuments), and the Atlantic Richfield Oil Building. Shown here in the 1940s, it was home to the First National Bank of Orange at the time, and was a rare example of a foray into Orange County on the part of the renowned architectural trio.

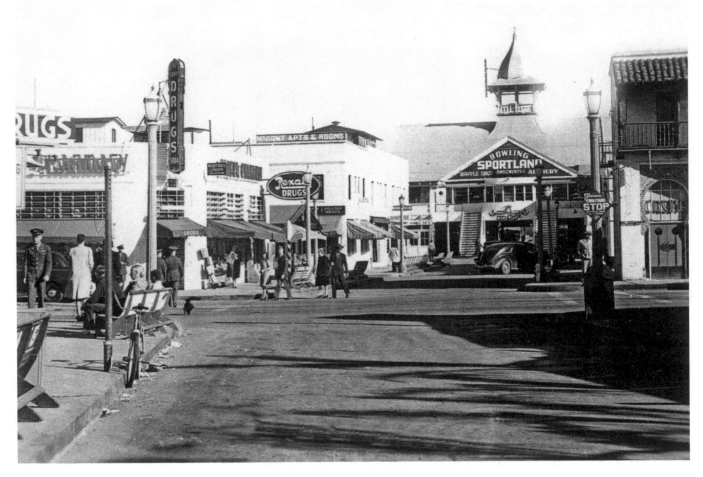

In 1928 competition from the newly opened Rendezvous Ballroom ended Balboa Pavilion's heyday as a dance hall. By the 1940s, when this photo was taken, the peninsula landmark had become "Sportland," offering bowling, archery, and other "amusements" that tied it thematically to the newly opened Fun Zone immediately adjacent. An upstairs room briefly offered "Skil-O-Quiz" bingo.

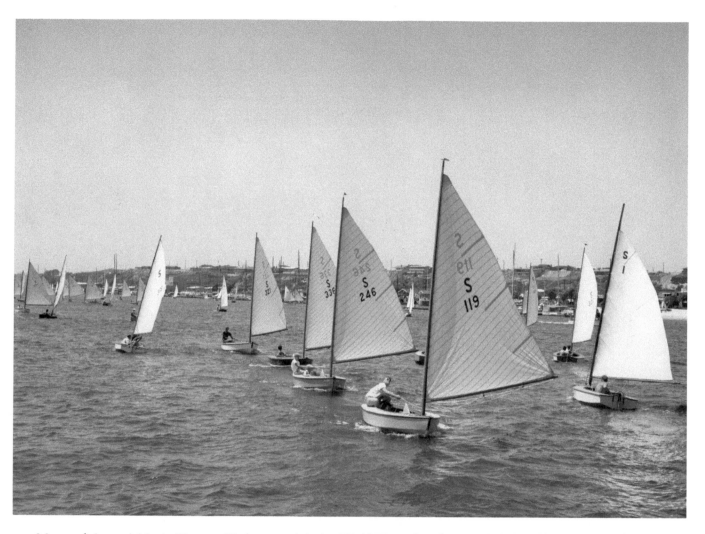

Most yachting activities in Newport Harbor ceased during World War II, but the annual Flight of the Snowbirds sailboat race, shown here in the 1940s, continued throughout the war years. Renamed the Flight of the Lasers in 1970, the event remains a Newport tradition and is now an all-ages event with prizes awarded in such categories as "First Married Couple," "First Parent-Child Team" and "Best Decorated Boat."

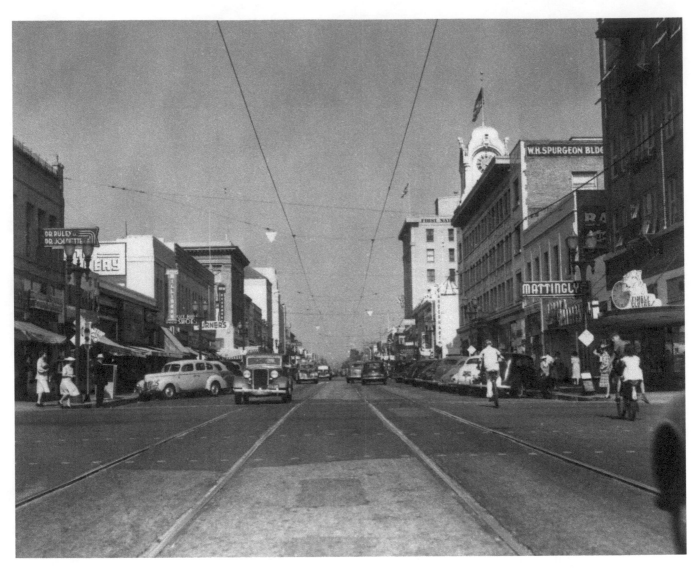

Santa Ana's four-story Spurgeon Building, shown here at right, was erected in 1913 by William Spurgeon, the town's founder. In the 1920s and 1930s, the Spurgeon was a fashionable business address. Today it houses artists' studios. For many years the four-sided clock tower crowning the building chimed and played military marches on the hour. A $90,000 restoration was undertaken in 1999 to restore the clock to its former glory.

This photo of Corona Del Mar shows the business and shopping district along the Pacific Coast Highway. All streets that cross the highway in the downtown area are named after flowers, in alphabetical order from Acacia to Poppy, and each is uniquely landscaped. Corona Del Mar is home to the Sherman Library and Gardens—a nonprofit garden, library, and historical research center dedicated to the flora of the Pacific Southwest.

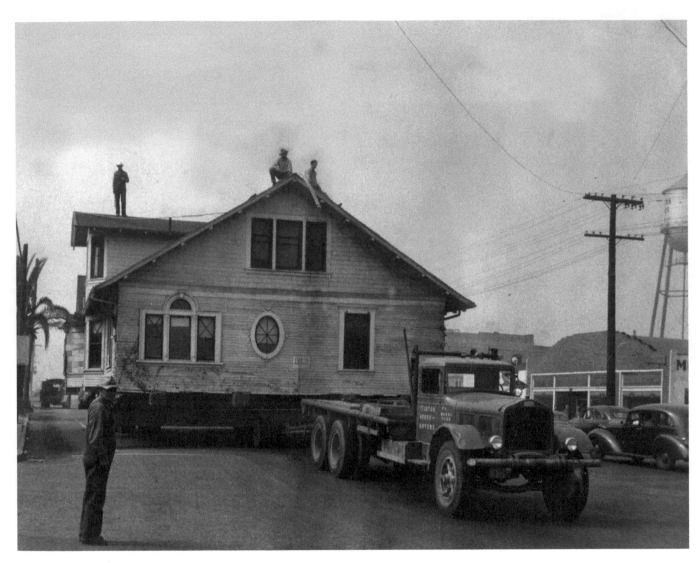

Shown here in 1943, the Weatherly House of La Palma is being sloooowly moved through Buena Park by Stanton House Movers. The historic districts of many Orange County towns, including Buena Park, were created by relocating historically significant buildings from areas threatened by development.

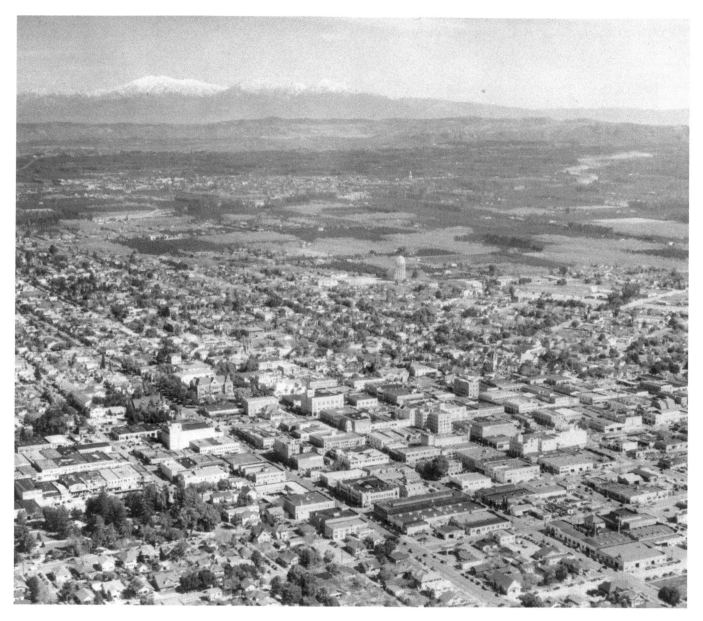

On the day of its incorporation in 1886, Santa Ana counted just under 3,600 people living within the city limits and on the surrounding farmlands. Some 50 years later, around the time this aerial photo was taken, the population had jumped to 32,000. Another 50 years hence that number would be ten times greater. The unprecedented growth of the postwar years would blur the borders of OC's cities and make annexation the only feasible means of expansion.

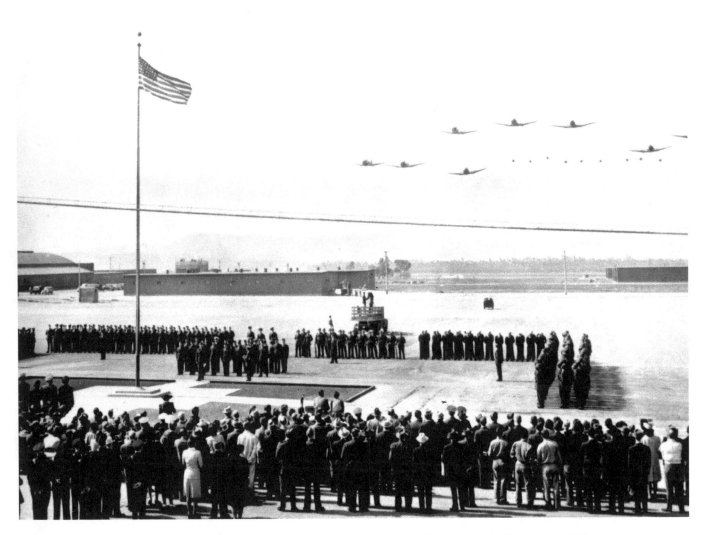

In 1942, when Lieutenant Colonel William Fox flew over Orange County searching for a suitable site on which to locate a Marine Corps air station, the area was still largely orange groves and wide-open spaces. By the time the El Toro station, shown here on opening day, March 17, 1943, officially closed in 1999, suburbia was encroaching on all sides, and a decade of controversy ensued over the facility's future.

ENDLESS SUMMER

(1946–1960s)

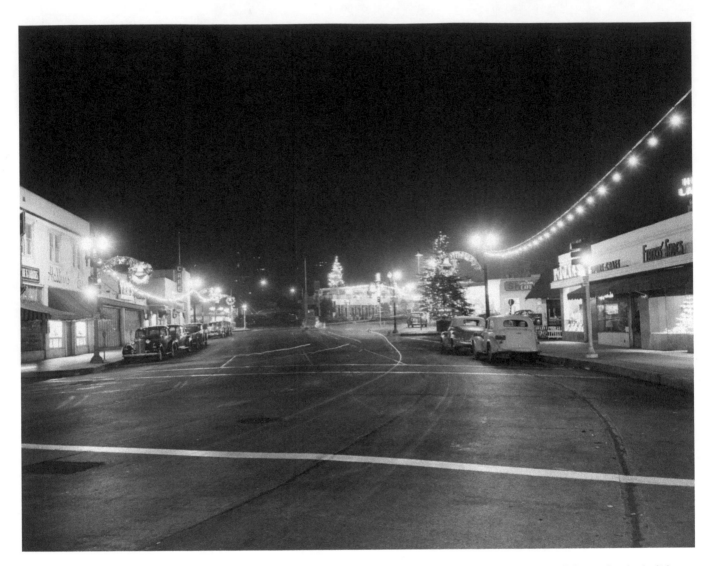

The war had been over for a year and a half when this peaceful shot was taken of downtown Laguna Beach lit up for the holidays. In the postwar boom that would soon overtake most of Orange County, the city of Laguna Beach would become a top tourist destination, renowned for art, stunning ocean-view property, fine dining, and dozens of beautiful beaches, each unique.

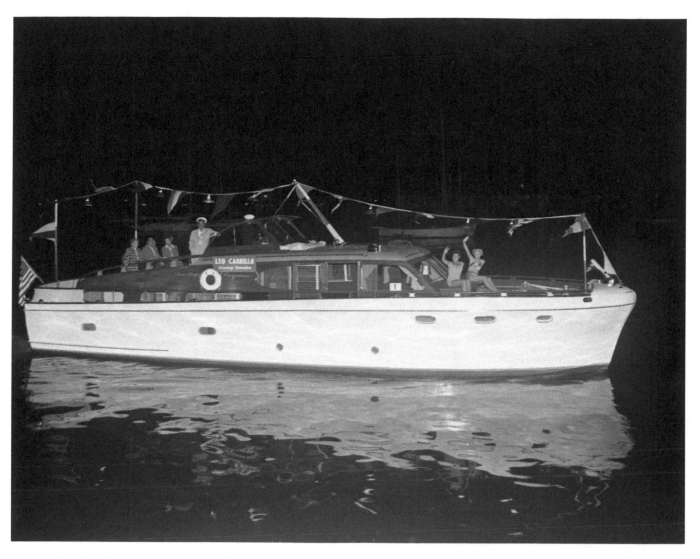

Actor Leo Carrillo, best known as Pancho in the 1950s television series *The Cisco Kid,* was an ardent preservationist (a state park near Malibu is named for him) and boater. He is shown here participating in the late-1940s Newport Harbor boat parade, a predecessor of today's Newport Beach Christmas Boat Parade, a five-day event featuring up to 150 lighted boats. This Yuletide classic attracts 200,000 people annually.

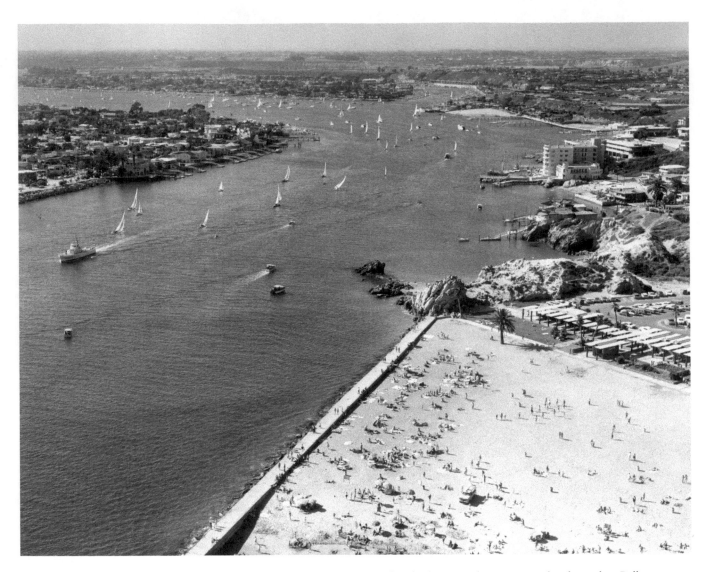

This gorgeous 1950s shot of Corona del Mar, seen at lower-right, was taken looking northwest across the channel to Balboa Peninsula. The most daunting challenge faced by early developers of Newport Harbor was the treacherous channel, which was shallow and riddled with hidden sandbars. Many lives were lost attempting to navigate it before the jetties were improved and the harbor dredged in the 1930s. Balboa Island was created with the sand that was removed.

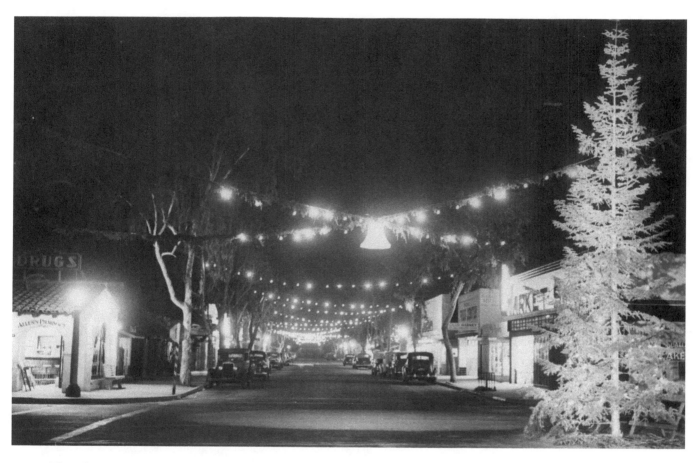

Though temperatures in Orange County in December are typically in the 60s, and the chance of snow is remote (to say the least), the residents of the tiny island of Balboa in Newport Beach have Christmas cheer in abundance. This 1950s view of Marine Street from Park Avenue reveals a town eager to put wartime rationing and blackouts behind it.

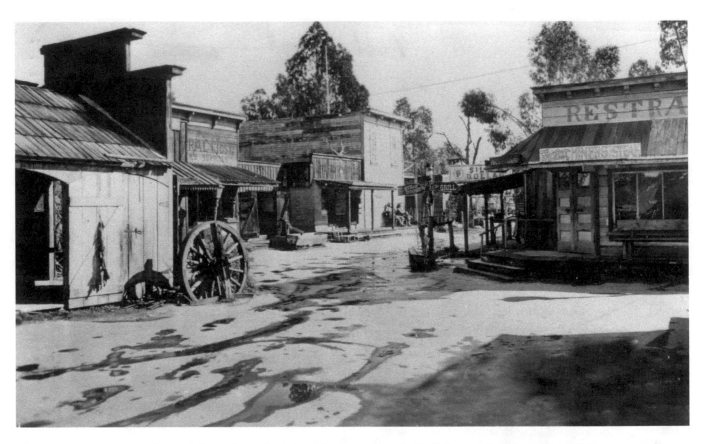

The Ghost Town section of Knott's Berry Farm, built in 1940, is composed of buildings and artifacts relocated from actual Arizona and California ghost towns by founder Walter Knott. The success of Knott's, considered "America's first theme park," paved the way for a slew of other tourist attractions that would follow in the 1960s. Although other areas of the park have succumbed to modernization, Ghost Town today looks much as it did in this 1950s photo.

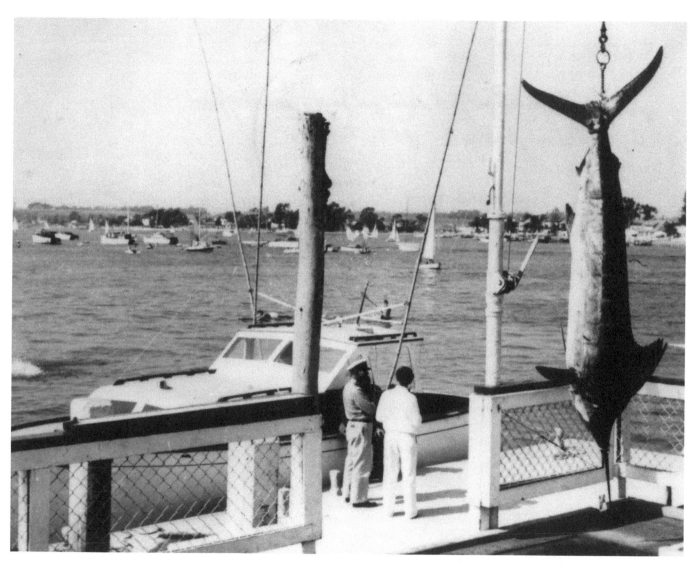

The Balboa Angling Club was formed in 1926, and the first official weigh station was located on Washington Street next to the harbormaster's office. Newport Harbor at the time was close to sport-fishing heaven, and marlin catches like this one, around 1950, were not uncommon. Overfishing and increased regulations have since affected the sport. The Balboa Angling Club today promotes conservation and the catch-and-release program

A single-engine Piper aircraft sits in front of the control tower at Orange County Airport in this 1950s photograph. The airport originated in the 1920s as a private landing strip built by aviation pioneer Eddie Martin. During World War II, it was requisitioned by the military for defense purposes. Renamed John Wayne Airport in 1979 in honor of one of the country's most famous residents, the facility features a larger-than-life bronze statue of the actor, created by sculptor Robert Summers.

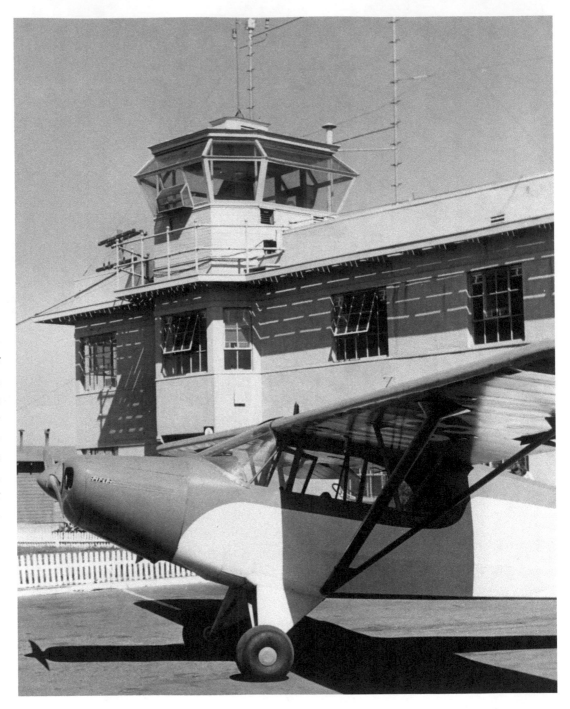

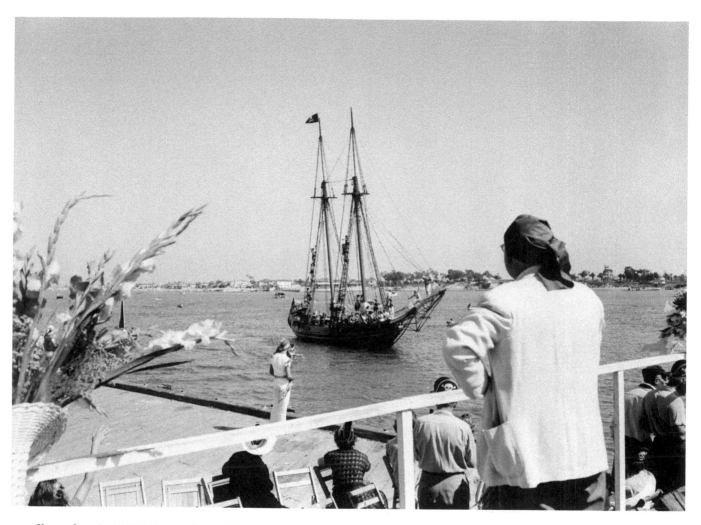

Shown here in 1953 is James Cagney's boat the *Swift,* a replica of an American-made brig captured by the British in 1783. Recreated as a topsail schooner in 1938, Cagney's *Swift* was featured in numerous Hollywood pirate movies and in more recent times has been available for charter and research. Between 1938 and 1948 Cagney owned tiny Collins Island, off the northwest tip of Balboa Island, leasing it to the Coast Guard during World War II.

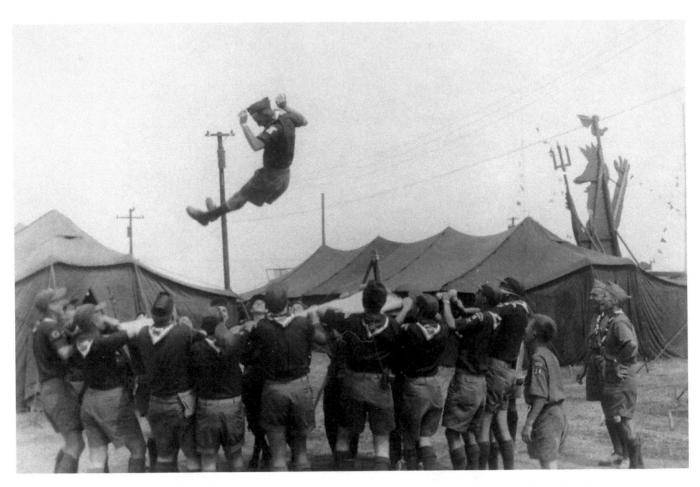

In 1953, 50,000 Boy Scouts from across the nation convened at the 3,000-acre Irvine Ranch in southern Orange County for the National Scout Jamboree, held every four years. The site was chosen from a field of 21 competing American venues. Shown here is the Jamboree blanket toss. The wooden sign at right is the reverse side of a King Neptune caricature welcoming the Scouts. A pelican perches on his head.

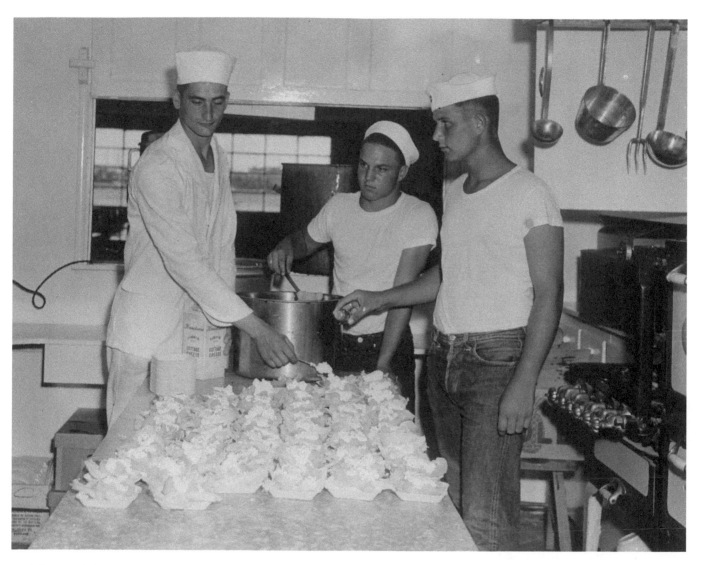

A full year of planning on the part of the National Boy Scout Council was required to ready transportation, sanitary facilities, and provisions for the Irvine Ranch Boy Scout Jamboree, which took place July 17-23. Kitchens at Newport Sea Base were pressed into service for preparation of the more than one million meals consumed that week by Scouts and troop leaders. Today Jamboree Road in Irvine commemorates the event.

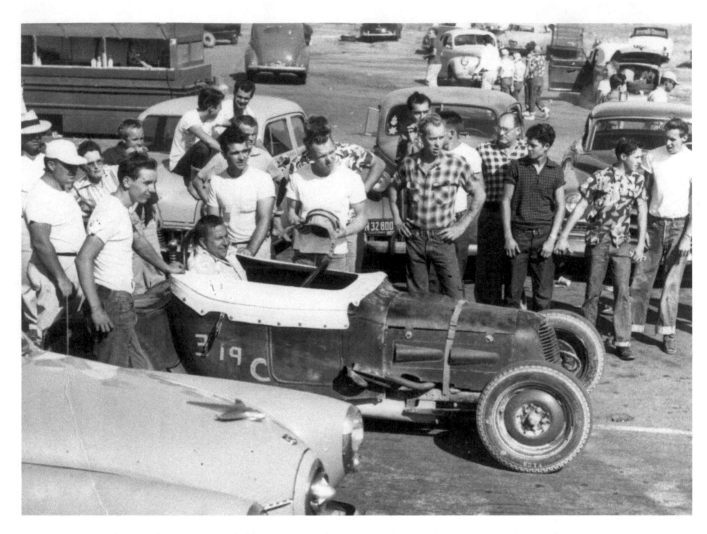

Between 1950 and 1959, drag races were held on an unused runway at Orange County Airport (now John Wayne Airport). Founded by C. J. "Pappy" Hart and Creighton Hunter, Santa Ana Drags was the first professional drag strip to charge admission and featured revolutionary, computerized speed clocks. The races were later moved to the Los Angeles County fairgrounds in Pomona. The man seated in the hot rod is possible Creighton Hunter.

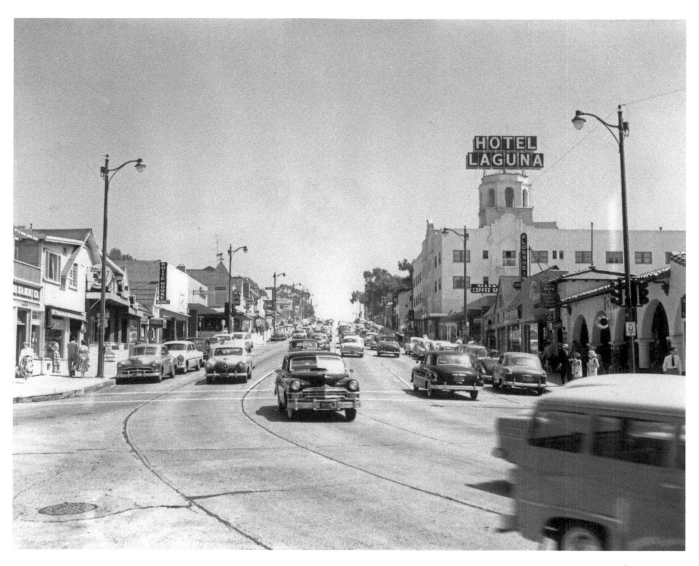

Laguna Beach's Yoch Hotel was condemned in 1928, and in its place rosc Hotel Laguna, pictured here in 1954. The hotel was designed in the Mission Revival style popular at the time, with parapets, a bell tower, and an inner courtyard. Unfortunately it opened in the middle of the Great Depression, and at one point had only five registered guests. Luckily a celebrity clientele soon discovered the place, and Hotel Laguna is still in business today.

In the 1950s, 1960, and 1970s, Buena Park hosted an assortment of unique tourist attractions, including the California Alligator Farm, which opened in 1954 directly across La Palma Avenue from Knott's Berry Farm. Here guests could feed an assortment of alligators and tortoises and even pose for pictures astride one of the giant reptiles. The Alligator Farm closed in 1983, and the site is currently an overflow parking lot for Knott's.

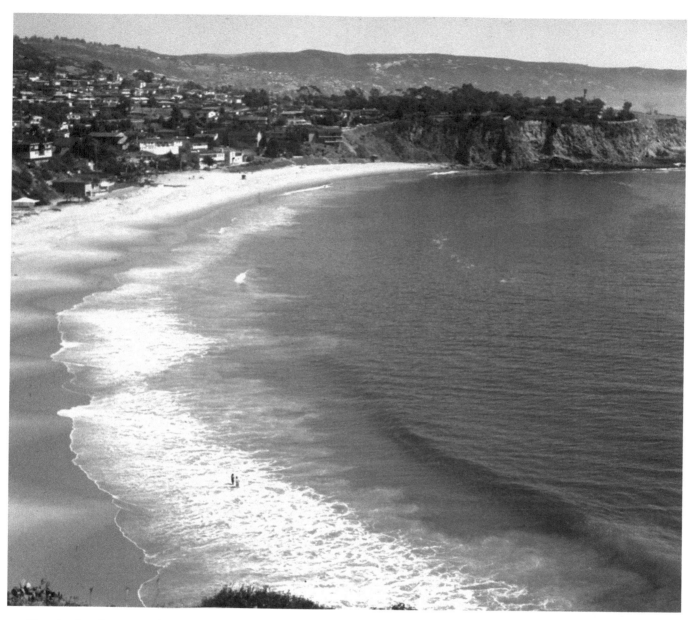

Two tiny beachgoers are dwarfed by the majestic natural wonders of Emerald Bay, shown here in 1956 as viewed looking south along the coast. Emerald Bay, not to be confused with Emerald Bay State Park near Lake Tahoe, or Emerald Bay Boy Scout Camp on Catalina Island, is an extremely exclusive coastal community just north of Laguna Beach where houses are currently selling in the $16 million range.

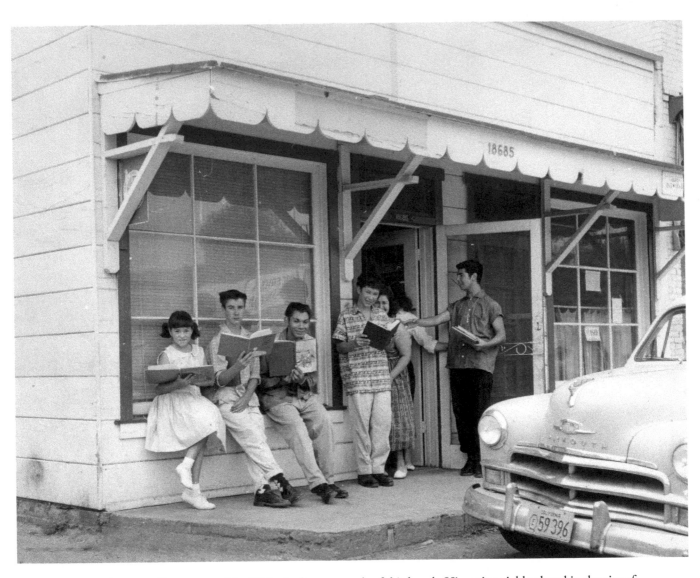

Before the El Modena city library opened in 1978, the literary needs of this largely Hispanic neighborhood in the city of Orange were met by a branch of the county library system that operated out of a storefront on Chapman Avenue next to Rice's Market, as shown here in 1957. Today the Orange County library system has 27 branches. Additionally, three city libraries served the city of Orange.

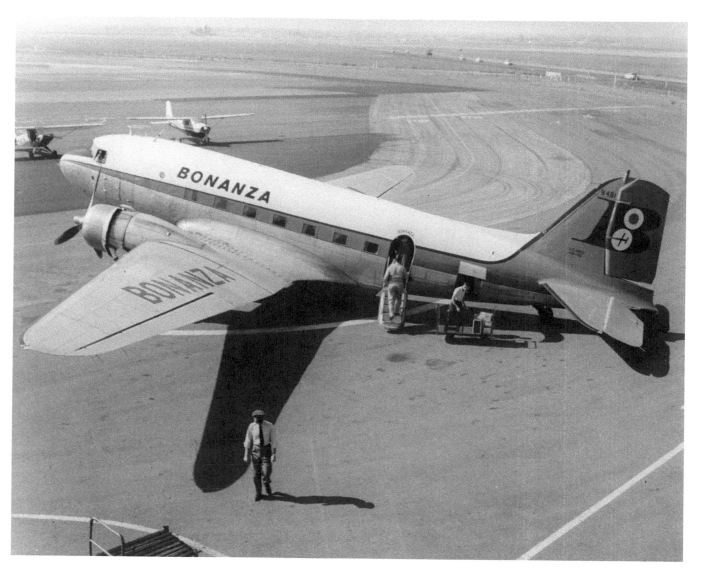

Las Vegas–based Bonanza Airlines, formed in 1946, ferried merchant marines from Southern California to the East Coast after World War II, and in 1952 launched the first scheduled airline service at Orange County Airport with a fleet of DC-3s, one of which is shown here in 1958. After two decades of operation, Bonanza merged with Pacific Airlines and West Coast Airlines in 1967 to form Air West.

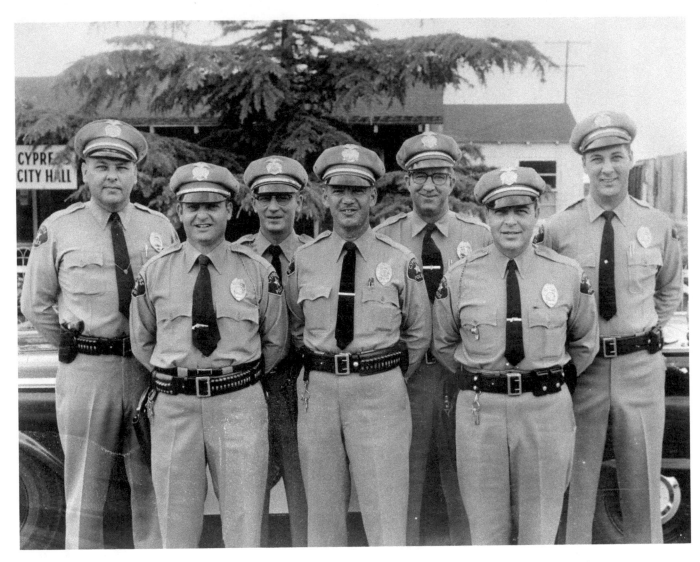

In a four-year period between 1953 and 1957, at the height of the postwar construction boom, eight Orange County towns incorporated to avoid annexation to neighboring Anaheim. Before Cypress voted to become a city in 1956, the community was known as Dairyland, with a population of 1,700 people and 100,000 cows. Needless to say, there are no longer any cows in Cypress. The city's recently formed police department is shown here in 1959.

The city of San Juan Capistrano, shown here in 1959 (in the days of 29 cent gasoline!), grew up around the mission, the entrance to which is visible at the end of the street. Each year the city marks the return of the swallows to the mission with Fiesta de las Golondrinas, a month-long celebration featuring the nation's largest non-motorized parade, performances by Aztec dancers and mariachi musicians, and a costumed ball celebrating the area's rich, multicultural history.

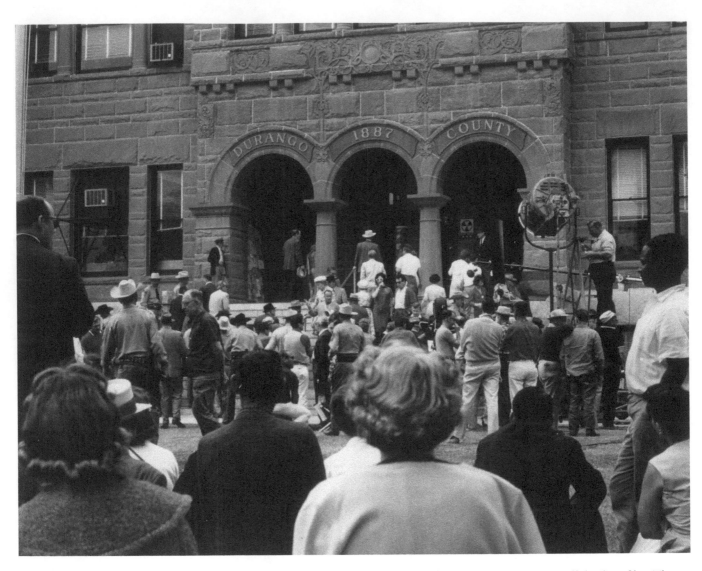

The Santa Ana County Courthouse has played host to many celebrities over the years. The 1915 D. W. Griffith silent film *The Flying Torpedo* and the 1978 miniseries *Studs Lonigan* are just two examples of the many Hollywood productions lensed in and around the photogenic site. Here the courthouse substitutes for "Durango County" around 1887 for a Western being filmed in the 1960s in front of a crowd of fans.

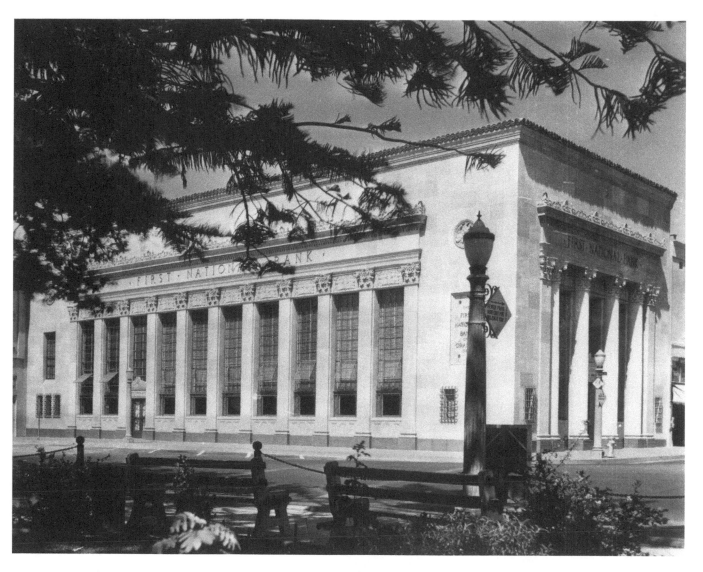

Located at 101 East Chapman, this imposing building continues to anchor the city of Orange's historic Plaza area and has changed little in nearly a century. Shown in the 1960s when it was still occupied by the First National Bank of Orange, it is currently home to a Wells Fargo and a Starbucks. Much of the original vaulted ceiling, composed of hand-carved, inlaid wood, is still visible inside.

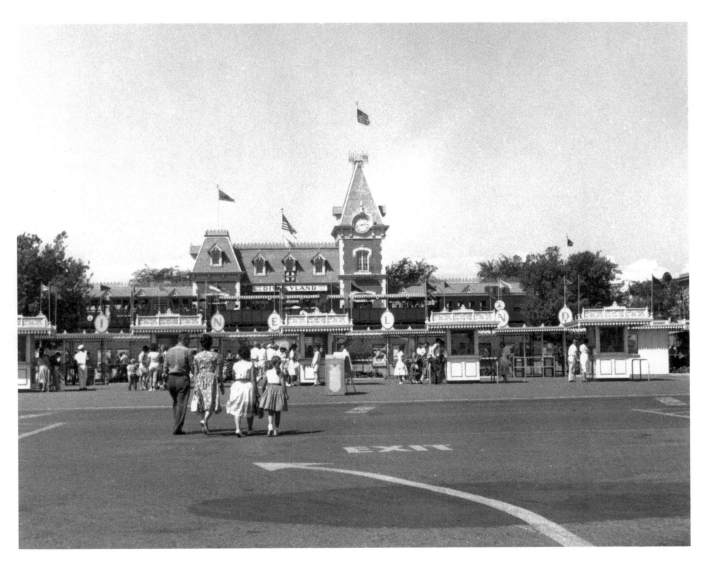

Disneyland opened in Anaheim in 1955 and, much to the surprise of its many detractors (including Walt's brother Ray), proved an immediate success, transforming the city around it and quickly becoming Anaheim's biggest employer. Shown here in 1960, Disneyland today attracts 13 million visitors annually and has grown to encompass Downtown Disneyland and also California Adventure, a separate theme park dedicated to California history.

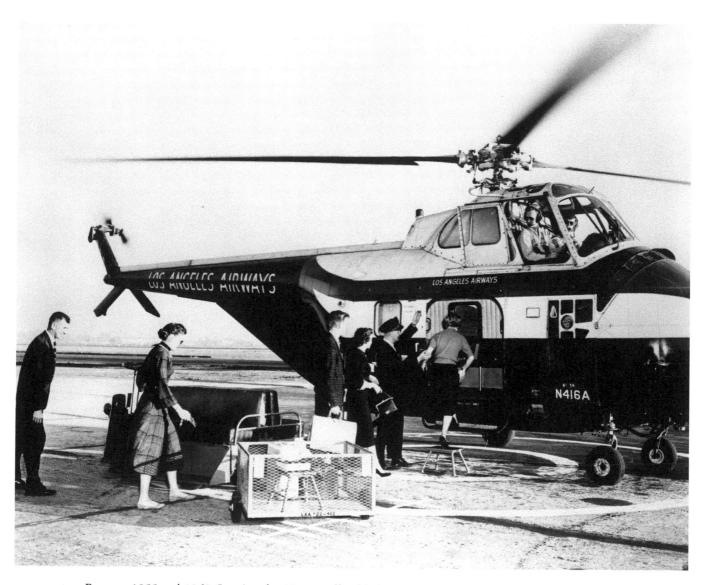

Between 1955 and 1968, Los Angeles Airways offered helicopter passenger service between Los Angeles International Airport and Disneyland. A 1963 *National Geographic* advertisement for United Airlines claimed, "You can step from a United jet, walk a few steps, and board a convenient flight to Disneyland and seventeen other points...what could be more convenient?" Service was discontinued after a 1968 crash killed eighteen.

Notes on the Photographs

These notes, listed by page number, attempt to include all aspects known of the photographs. Each of the photographs is identified by the page number, a title or description, photographer and collection, archive, and call or box number when applicable. Although every attempt was made to collect all data, in some cases complete data may have been unavailable due to the age and condition of some of the photographs and records.

Printed in the USA
CPSIA information can be obtained
at www.ICGtesting.com
JSHW072022140824
68134JS00042B/3741